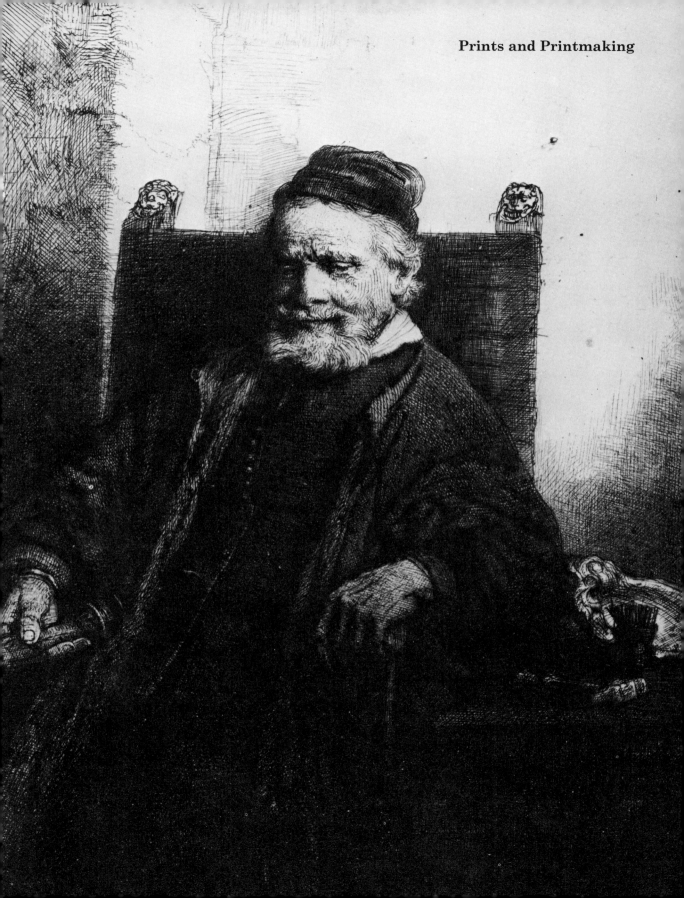

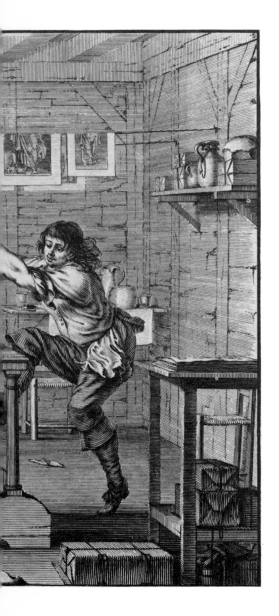
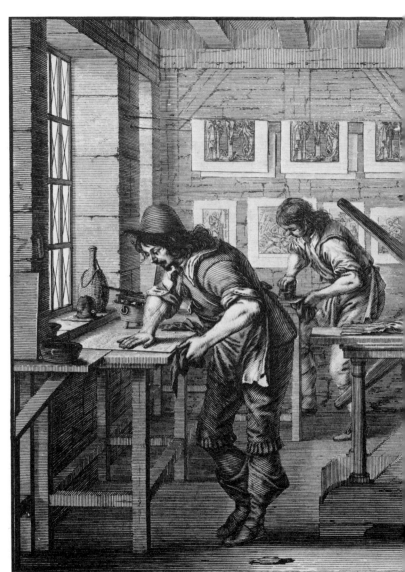

Prints and Printmaking
An Introduction to the history and techniques

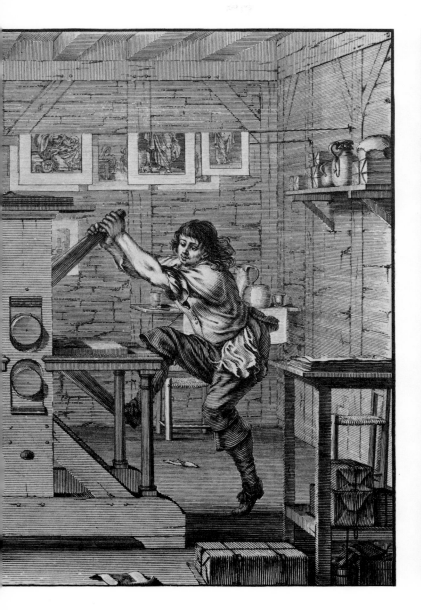

Published by British Museum Publications Limited

FRONT COVER Emil Nolde, *Junges Paar*, 1913.
Colour lithograph.
BACK COVER Aegidius Sadeler, *The Great Hall in
the Castle at Prague*, 1607. Etching (detail).

© 1980, The Trustees of the British Museum
ISBN 0 7141 0769 7 (paper)
ISBN 0 7141 0770 0 (cased)
Published by British Museum Publications Ltd,
6 Bedford Square, London WC1B 3RA

British Library Cataloguing in Publication Data

Griffiths, Antony
 Prints and printmaking.
 1. Prints – History
 2. Prints – Technique
 I. Title
 760'.28 NE400

ISBN 0-7141-0769-7 Pbk
ISBN 0-7141-0770-0

Designed by Roger Davies
Set in Monophoto Century by
Filmtype Services Limited, Scarborough
and Printed in Great Britain by W. S. Cowell Ltd,
at the Butter Market, Ipswich

Contents

Preface

In 1914 the Trustees of the British Museum published a *Guide to the Processes and Schools of Engraving* written by A. M. Hind, later Keeper of the Department of Prints and Drawings. This admirably succinct and lucid booklet quickly became a standard introductory work and was reprinted in successive editions, the last of which (the fourth) was published in 1952. It has now been out of print for many years, and since it has become outdated in several respects, the opportunity has been taken to expand and recast the form of the text and to add sections on screenprinting and the photomechanical processes. Much miscellaneous information which Hind put in his final section has been cast in the form of a glossary. This work has been carried out under my close supervision by A. V. Griffiths, Assistant Keeper in the Department. Although little of Hind's phrasing survives, the intention and the scope of the work remain unchanged. It is meant as an introduction to a complicated subject for those who wish to acquire a basic knowledge. Accordingly, the text has been deliberately kept as simple as possible; it is not intended to instruct the practising printmaker (for whom many suitable manuals already exist), and will contain little new for the print historian. Like Hind's book, it is restricted to prints of the western world, and neglects modern developments in favour of a fuller historical account.

The illustrations are a new feature of this revision, and have been chosen to complement the text rather than to act as an anthology of fine prints. Wherever possible black and white prints have been reproduced in their actual size and this has entailed the exclusion of most large prints. All reproductions are made from originals in the Department of Prints and Drawings in the British Museum, except for **29** which is in the Department of Greek and Roman Antiquities.

The author wishes me to express his thanks to Mr Adrian Eeles and Mr Richard Godfrey for reading an early draft of the text and suggesting many improvements, and to Mr Peter Freeth for his expert advice on intaglio techniques, and to David Landau for reading the final proofs. The Department is also indebted to Mr Graham Javes of the Photographic Service, who has taken exceptional pains to provide excellent photographs for the illustrations, and to Mr Eric Harding, Chief Conservation Officer, for the macrophotographic enlargements of details. Illustrations **95** and **121**, and colour plate 12, are reproduced by kind permission of the artists.

J. A. GERE
Keeper, Department of Prints and Drawings.

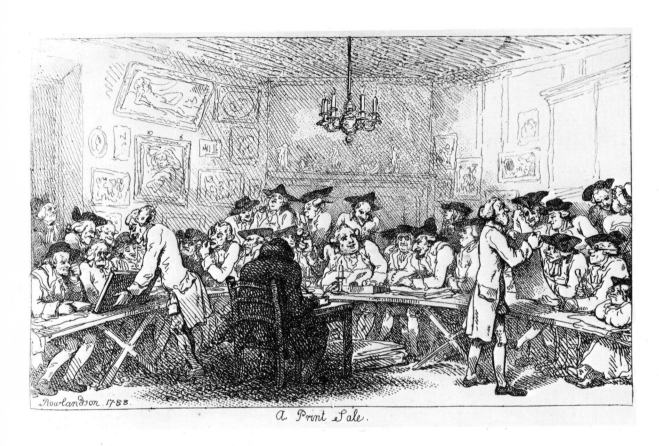

1 Thomas Rowlandson *A Print Sale*, 1788. Etching (reduced).

What is a print?

Many of the best-known works by some of the world's greatest artists are prints (one thinks of Dürer, Rembrandt and Goya), and most people must own at least a few prints themselves. It is, then, surprising that so little is generally known about the subject. Few people, even among professional art historians, know the difference between an etching and a lithograph, or could tell a reproduction of a print from an original. The subject is, however, complicated and there are no short cuts to acquiring a basic knowledge of the various techniques used to make prints, a knowledge of which is the essential foundation of an intelligent appreciation of the printmaker's achievements. This is, of course, also true in other fields of artistic activity. There is no point in criticizing a painting for lack of chiaroscuro if it is, in fact, a fresco, or a vase for lack of translucency if it is earthenware; similarly it is necessary to realize that a woodcut cannot reproduce the effect of chalk, nor an etched line an area of continuous tone.

A print is in essence a pictorial image which has been produced by a process which enables it to be multiplied. Therefore, it requires the previous design and manufacture of a printing surface; at its simplest this can be a cut potato, but the standard materials have been wood, metal or stone. These are inked and impressed on to a suitable surface, usually a sheet of paper or a closely related material such as satin or vellum; the many important applications of printing images on to textiles, ceramics or plastics have traditionally been excluded from the field of prints.

An essential feature of prints is their multiplication and this often causes puzzlement. How, people ask, can a print be an original work by (say) Rembrandt when there are other impressions exactly similar to it? But this conceptual difficulty does not seem to be felt in other fields. No one is worried by the existence of multiple porcelain figurines or statuettes cast from the same model. They are all held to be original works by an artist such as Bustelli or Giambologna. At a more sophisticated level it is sometimes held that a print is a secondary object as compared with a painting or, more particularly, a drawing: the print is simply a drawing which the artist made on wood or copper or stone in order to be able to turn out many copies of it. Therefore, it is held, a drawing on paper must be superior since it preserves the direct intention of the artist without the distorting filter of the reproductive process. This objection is groundless. Printmaking's unique possibilities arising from the interaction between printing ink and paper, produce aesthetic effects unrealizable in any other way. These beauties, as with any aesthetic quality, may not be immediately apparent, but the eye will soon be educated into their appreciation by an attentive study of fine impressions. Thus the great prints of the world are not reproduced drawings but works of art deliberately created through the medium of printing. It is for this reason that a

Rembrandt copper plate, although directly worked by the artist himself, is of no artistic importance compared with any impression taken from it.

One other objection to prints sometimes held by students of drawings should be mentioned. Since most drawings are preparatory studies for paintings, their connoisseur tends to become interested above all in the evidence of the artist's mind at work in the creation of a composition; such concerns are absent in prints, which are accordingly dismissed. This objection is misconceived. Those who prefer drawings are welcome to do so, but they should not look for the concerns of a drawing in a print. A print is a finished composition and an end product of the creative process, and in this respect stands closer to a painting than to a drawing.

A fundamental change in the status of the print occurred in the middle of the nineteenth century. Photography was invented in the 1820s, and various methods were soon developed of applying it to the production of printing surfaces. The new photomechanical technology has managed in the first place thoroughly to confuse the public mind about the status of artists' prints, and secondly to devalue the print as an art object.

The discussion of the first of these effects can be linked with an elucidation of the two possible meanings of the term, an 'original' print. Before the invention of photography every surface used for printing had to be prepared by hand by non-photomechanical processes. In this period the principal division that can usually be made among prints is between the reproductive and the non-reproductive. A reproductive print reproduced a work created in a different medium; the most obvious example is an engraving after a painting. Before the invention of photography the demand for work of this sort was enormous and generations of expert reproductive engravers were trained to satisfy it. However, the print need not be confined to such work, and occasionally the medium was taken up by a creative artist who was attracted by the range of textures and effects which can be obtained only in a print. Such artists made prints which are in no sense reproductive and which are as important products of their creative genius as their paintings and drawings. For this reason they are sometimes called 'painter-engravers' – a clumsy translation of the French 'peintre-graveur'. This category of 'artist's' print is often called 'original', and is in this sense opposed to 'reproductive'.

The invention of automated photomechanical processes produced a new category of print. For all reproductive purposes it was very much cheaper and more accurate and therefore replaced the previous type of hand-made reproductive print. Since the most widespread use of prints has always been for reproductive purposes, the photomechanical print has become the sort of print which is above all familiar to the public, whether as book

illustrations, as posters or as framed reproductions for room decoration. By comparison a non-photomechanical print has become a rarity, and many people are not even aware that such a category exists.

The question now is what terms we should use to distinguish these two classes. This is always done by opposing 'photomechanical' to 'original' prints. The only trouble with this terminology is that 'original' in this context means something quite different from what it meant two paragraphs ago when it was opposed to 'reproductive'. Unfortunately this ambiguity is too deeply embedded in the literature of the subject to be avoided, but the context should always make clear which meaning a writer has in mind.

The photomechanical reproductive print has put the artist or original printmaker at a serious disadvantage. As photomechanical reproduction became better and cheaper, the inevitably greater cost of printing by hand made it necessary to adopt more sophisticated marketing methods. In earlier centuries the number of impressions printed was limited only by demand or by the condition of the plate. Since the later nineteenth century artificial rarity has been created by the production of limited and numbered editions, usually signed in pencil in the margin by the artist. This device has helped to sell prints, but at the cost of attracting attention to irrelevancies, and pandering to the speculator and autograph collector. In fact the presence of a signature has often been taken as a guarantee that the print is an 'original' created by that artist. But this convention has been stood on its head by many artists who have happily (and perfectly reasonably) signed limited editions of high-quality photomechanical reproductions of their paintings.

The desire to help the public distinguish original printmaking from photomechanical reproduction also lay behind the misguided establishment of various committees to provide simple definitions of an 'original' print. These, very confusingly, were usually drawn up in terms of permissible and impermissible *processes* of manufacturing printing surfaces (hand-made surfaces were acceptable, photomechanically produced ones were not). They served a purpose as long as original printmakers did in fact stick to entirely non-photomechanical processes, but since about 1960 this has ceased to be so. Many of the best prints of recent years have incorporated photomechanically reproduced imagery, and some indeed are entirely collages of such imagery. Such prints of course remain in every way 'original' because the photomechanical processes are here being used not to make a facsimile of an already extant work of art, but to create a new one which only finds its embodiment in the resulting print. What matters, as always, is the artistic intention and effect.

The other, less obvious, consequence of the photomechanical revolution has been to devalue the print as an art object. Photo-

11

mechanical reproductions of paintings are merely adequate, but those of prints can be astoundingly good. Line-block reproductions of woodcuts and photogravure reproductions of engravings and etchings, because they use the same methods of printing and the same media of ink and paper, can sometimes be difficult to distinguish from their originals. An idea, therefore, has developed that there is no need to study a print in the original, unlike drawings or paintings which are so much more difficult to reproduce. Human factors too come into play: since impressions of prints can be seen in many collections there is less urgency to look at them than at items which are unique. But of course impressions of prints do vary, and reproductions are not substitutes for the originals. As Kenneth Clark has observed: 'The study of Rembrandt's etchings through reproduction is a kind of visual corruption, and one must return to the originals as often as possible.'

Relief Printing Processes

There are various different types of relief process used in printmaking. They are classed as members of the same family because in each the actual surface from which the printing is to be done stands in relief above the rest of the block which has been cut away. Ink is applied to the surface of the block, and is transferred to paper by applying a light vertical pressure. The most important of the relief processes are woodcut and wood-engraving.

Woodcut

Technique The material used is a wooden block, usually about an inch thick. It is always part of the plank of a tree of fairly soft wood, eg. pear, sycamore or beech, sawn lengthwise along the grain, and planed down until smooth. Before use it must be seasoned to ensure that it will not warp or crack.

The artist's design is either drawn directly on the block or on a sheet of paper which is then glued to its surface. The cutter uses a knife similar to a penknife, and carefully cuts all the wood away from the sides of the lines which the artist has drawn. Chisels and gouges can be used to cut away any large areas of space. When finished the image will appear as a network of lines standing out in relief.

The cutting of the wood is a skilled business, and from early times it was usual for the artist only to make the design on the surface of the block and then hand it over for cutting to a professional woodcutter. It will be obvious that the cutter can only cope with a design drawn in lines, and if shading is required the conventions of parallel or cross hatching must be used; with cross hatching the cutter has laboriously to cut out all the interstices between the hatchings. If a mistake is made and too much has been cut away, the cutter has to make a hole in the block and insert a new plug of wood.

The surface of the block is inked using a dabber or (from the early nineteenth century onwards) a roller; the printing ink has to be of a stiff consistency in order to remain on the raised parts of the block and not flow into the hollows. The printing is done in a press which is the same or at least works on the same principle as an ordinary type printing press; pressure is applied uniformly and vertically but need only be light. Woodcuts can be handprinted without using a press. The block can simply be stamped on to the paper, or paper can be laid on the block and the ink transferred by rubbing on the back of the paper. Most early woodcuts were probably printed by one of these methods.

Historical The art of printing from woodblocks was invented in China during the European Dark Ages. The stages by which it spread westwards are still little understood, but the probable use of woodblocks in Europe can be traced to the thirteenth century. This was confined to stamping designs onto textiles, and the

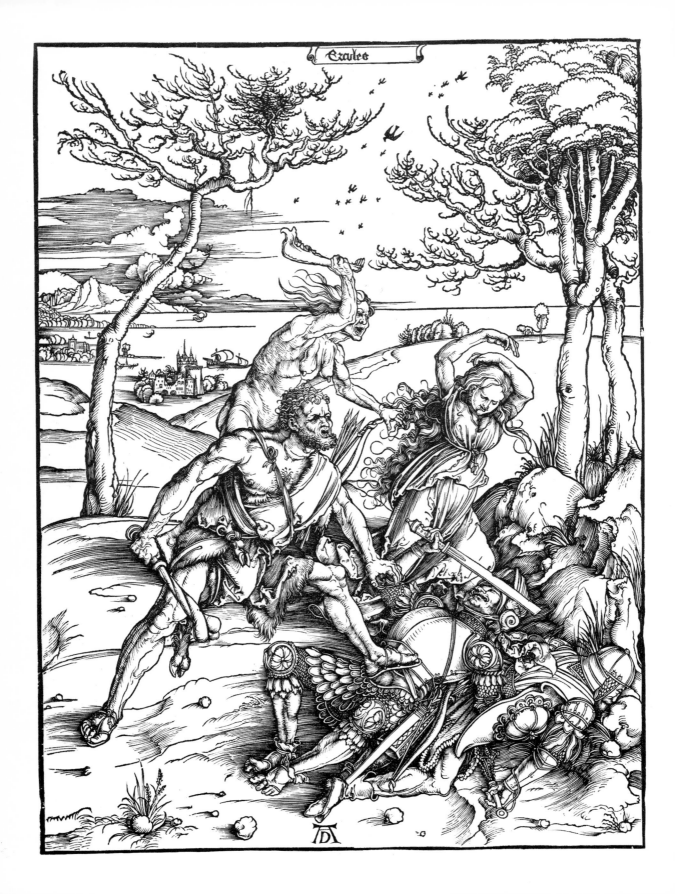

2 *left* Albrecht Dürer *Hercules, c.* 1496/7. Woodcut (greatly reduced).

3,4 *above* Detail of **2** (*left*) with the equivalent detail of the original wooden block (*right*) from which it was printed (both actual size). The block has been damaged since this impression was printed: note the worm-holes and flattened lines. The detail shows the skill of Dürer's cutters; for example, the shading on the arm is cut at an angle into the block so that the lines taper to a point when printed.

5,6 Jost Amman *The Woodcutter* (*right*) and *The Printer* (*far right*), 1568. Woodcuts (actual size). The cutter is using a knife. In the printing shop, the man on the right is inking the lines of type (and woodcut illustrations) with dabbers, while his companion is laying down a clean sheet of paper. The hinged frisket on the left will next be folded on top of the paper to hold it in position, the paper in turn hinged on top of the type and the whole slid to the right under the tympan of the press. This is forced down by pulling the handle horizontally.

7 *opposite* Anonymous, *Christ before Herod*, German, *c.* 1400. Woodcut (greatly reduced). One of the earliest surviving woodcuts.

earliest surviving prints on paper cannot be dated before the last years of the fourteenth century. The explanation of this delay must be found in the history of papermaking: until there was a reasonable supply of cheap paper the woodcut was a commercial impracticality, yet the earliest documented papermill in Italy, at Fabriano, was founded only in 1276, and in Germany none was founded before the fourteenth century.

Some of the earliest woodcuts, in the flowing style of the International Gothic, are surprisingly ambitious and sophisticated compositions, although their authors remain anonymous. Work of a similar quality is found later in the best of the blockbooks of the 1460s (see glossary), but, in general, from about the middle of the fifteenth century the medium became fixed at a humble artistic level, being used primarily for playing cards and religious images of a crude nature. (The special groups of flock, paste and seal prints are described in the glossary.) Hardly any of these are signed, and it has so far proved impossible to group them by designers; indeed, it has been found extremely difficult even to decide which country they come from. They were turned out in huge numbers to be sold at pilgrim shrines and fairs, or by pedlars. The corollary of their massive sale and widespread distribution is that they are now extremely rare, and very few are known in more than one impression. The contrast with the history of engraving is striking: all but the feeblest early engravings are either signed or can confidently be attributed to one of a handful of artists, some of them very distinguished; and, being relatively expensive, they were kept so that most survive in a number of impressions.

To an observer of the 1480s it must have appeared that the

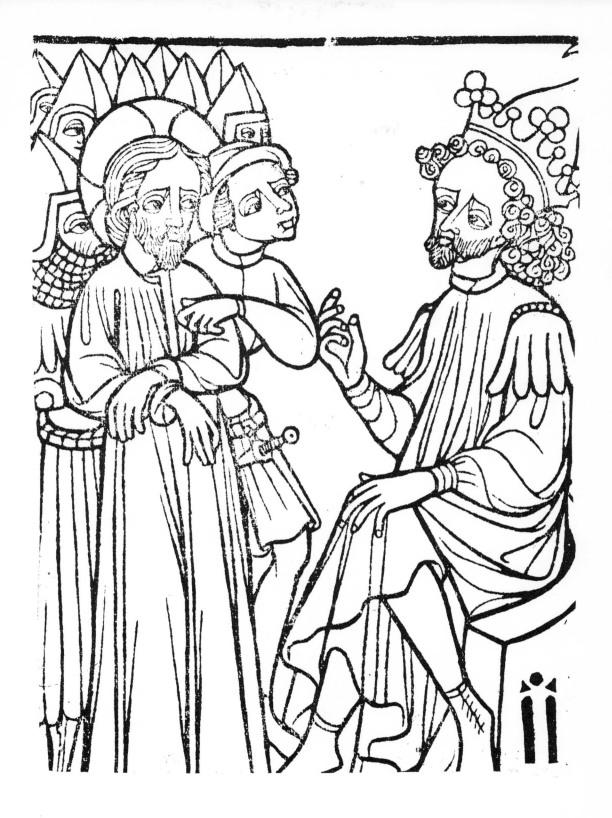

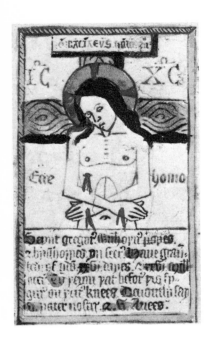

8 Anonymous, *Christ as the Man of Sorrows*, English, *c.* 1490. Woodcut, coloured by hand (reduced). The text offers an indulgence of 26,000 years to those that 'Devoutly say v pater noster & v Avees' in front of this image. An example of a popular woodcut, typical except for the fact that it is English.

woodcut was condemned to remain a minor popular art. Its revival in the 1490s was due to the book trade. For several decades after the appearance of Gutenberg's first printed book in 1453–5 the printer's aim had been to make the book look like a manuscript and, accordingly, printed illustrations were in general eschewed. In the 1490s, however, publishers realized that there was a market for illustrated books, and for book illustration woodcut was, commercially, the obvious method: it could be printed in the same press and at the same time as type, whereas an engraving would have to be separately printed in a different press.

This discovery was made in Nuremberg, and the first great illustrated book was the folio *Weltchronik* of 1493 for which Michael Wolgemut supplied the illustrations to Hartman Schedel's specially commissioned text. Albrecht Dürer (1471–1528), as an apprentice, played some part in this book, but realized that the woodcut had even greater potentialities. His own great series of designs, from the *Apocalypse* of 1499 to the *Great Passion* and *Life of the Virgin* published in 1511, were in fact printed with a facing text, but their brilliance established the woodcut as a major art form. In technique too they mark a major advance, for Dürer trained his cutters to produce a facsimile of every line of his drawing and thus realize designs of a far greater complexity and sophistication than had previously been thought possible (see p.15).

Dürer's example was decisive, and the first thirty years of the sixteenth century saw the greatest efflorescence in the history of the woodcut, both in single sheet designs and in book illustrations. It extended not simply to Dürer's pupils in Nuremberg such as Hans Springinklee and Hans Sebald Beham, but to almost all the leading German artists of the period; to Albrecht Altdorfer and the Danube School, to Lucas Cranach in Saxony, to Hans Baldung Grien in Strasburg and to Urs Graf (famous for his 'white-line' technique of design) and Hans Holbein in Switzerland. The most fascinating development was at the court of Maximilian, the Holy Roman Emperor. Maximilian, a man crushed between the dignity of an authority second only to the Pope's and the reality of political insignificance and chronic bankruptcy, was forced to proclaim his importance as cheaply as possible, and struck upon the ingenious idea of doing this through various gigantic series of woodcuts. Hans Burgkmair at Augsburg was the main artist involved, but Dürer and many others were also employed. Maximilian's early death unfortunately meant that most of these projects were left unfinished, but they remain the most impressive attempt at royal self-glorification through the print, a task more usually entrusted to the medium of painting or tapestry.

The upheaval of the Reformation in Germany gave birth to a flood of propaganda broadsheets, but the quality of woodcuts (as of German art in general) declined, as did the quantity. In the second

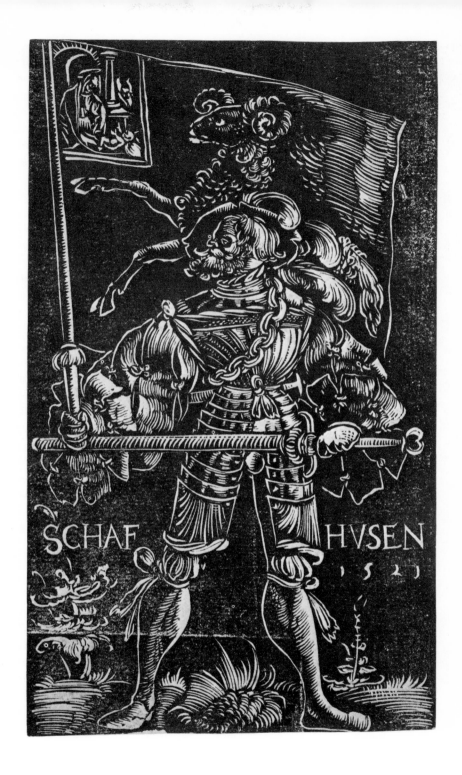

9 Urs Graf *Standard Bearer of Schaffhausen*, 1521. Woodcut (actual size). A rare example of a 'negative' or 'white-line' woodcut where the design is carried by the lines incised into the block.

half of the century a notable school of mannerist book illustrators flourished in Nuremberg around Virgil Solis and Jost Amman, but the business of the woodcutters received an almost deadly blow in the final years of the century when publishers decided to abandon the woodcut for book illustration in favour of intaglio methods. The reasons for this are not entirely clear, but must be related to the greater accuracy of detail which intaglio then allowed. The woodcut was henceforth thrust back into the uncharted depths of the popular broadsheet and chapbook.

The history of woodcutting in the Netherlands parallels that in Germany. Although many of the blockbooks seem to have been Netherlandish in origin, the fifteenth-century illustrated books were not distinguished. But in the early years of the sixteenth century, under Dürer's influence, Jacob Cornelisz. van Oostsanen, Lucas van Leyden, Pieter Coecke van Aelst and Cornelis Teunissen produced some superb designs, which are only little known because originals are so rare.

Italy and France were the only other countries to have a distinguished woodcut tradition. Italian fifteenth-century single sheet woodcuts are very rare, and it is uncertain whether this is due to the accidents of survival or to lack of production. The only significant Florentine tradition is to be found in the illustrations to some sermons by Savonarola and a series of *Sacre Rappresentazioni* published from the 1490s onwards. The Venetian tradition began with two outstanding oddities: the anonymous illustrations to Francesco Colonna's *Hypnerotomachia Poliphili* of 1499, and Jacopo de' Barbari's huge bird's-eye view of Venice of 1500. It continued with the landscape woodcuts designed by Domenico Campagnola, and the remarkably varied group of prints which seems to have been designed by Titian between 1510 and the 1540s. He inspired a crop of emulators in Venice, and one remarkable artist, Giuseppe Scolari, in Vicenza, who produced nine original and powerful cuts in the final decades of the century. Otherwise the woodcut found little following in Italy; the outstanding exception of the numerous chiaroscuro cuts is described in the section on colour printing.

As in Italy, French fifteenth-century single sheet woodcuts are rare; the splendid series of Books of Hours produced in Paris and Lyons in the 1490s was illustrated with metalcuts. The origin of the main sixteenth-century French tradition is to be found in Switzerland with Hans Holbein, whose *Dance of Death* and illustrations to the Old Testament, both superbly cut by Hans Lützelberger in Basle, were first published in Lyons in 1538. These directly inspired the designs of Bernard Salomon who kept the Lyons publishers supplied with book illustrations until his death in 1561.

The collapse of the woodcut tradition after 1600, both for single sheet prints and book illustrations, extends across Europe, and

only occasional attempts to revive it can be found in the seventeenth and eighteenth centuries. Between 1632 and 1636 Rubens employed Christoffel Jegher to cut nine blocks, but these were the only woodcuts among the numerous prints which issued from his studio. A few cuts can also be found in Holland by Jan Lievens (1607–74) and Dirk de Bray. In the eighteenth century William Hogarth made an interesting attempt to use woodcut to widen the circulation of his *Four Stages of Cruelty*. Two of the designs were cut by J. Bell and published in 1751, a month before the engravings of the same subjects. The project did not succeed, and the other two designs were never issued. This fiasco demonstrates the inadequacy of the woodcut for eighteenth-century requirements, while the commercial needs of the nineteenth century were met by the wood-engraving.

The woodcut was only seriously taken up again by Gauguin and Munch in the 1890s. Their work inspired the artists who formed the group called *Die Brücke* in Dresden in 1905: Ernst Ludwig Kirchner, Eric Heckel, Karl Schmidt-Rottluff and their later recruit Emil Nolde. Their aggressive designs, hacked directly into the block and heavily indebted to primitive art, caused great offence at the time, but can now be seen as the point of departure for the twentieth-century woodcut revival. This has continued to find its greatest following in the German-speaking countries, but has spread to other lands; the best known of these non-German artists is probably the American, Leonard Baskin.

This century has also seen the introduction of materials other than wood. The most popular alternative has been linoleum (whence the term 'lino-cut') which, being soft and grainless, is easy to cut, and for this reason has often appealed to amateurs and been used in schools. Artistically its main difference when compared with wood is its lack of a grain and the softness which can prevent a sharp line or the relief created by embossing which is apparent in many woodcuts. Linoleum seems first to have been used by various artists around the time of the First World War; it was widely publicized in Britain by Claude Flight in the late 1920s, but only achieved importance when taken up by Matisse in the late 1930s and by Picasso, who made a few cuts in 1939 and a much larger series in the years from 1958.

Wood-engraving

Technique Wood-engraving is in essence only a particular form of the woodcut developed in the eighteenth century, although in effect and appearance it is quite different.

In wood-engraving a very hard wood is used (usually boxwood), which is always cut across the grain ('end-grain'); since box has only a small diameter, large blocks have to be made by bolting

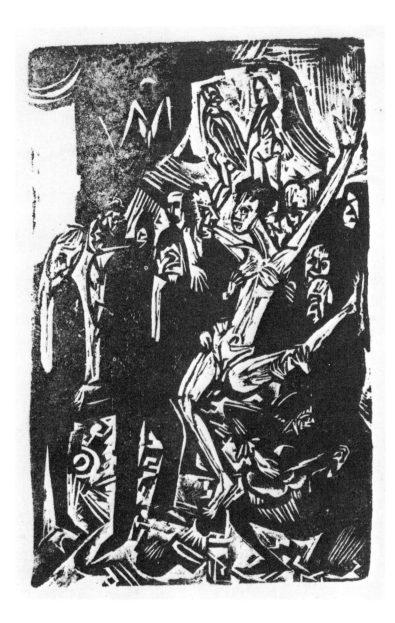

10 Ernst Ludwig Kirchner
Bordellszene, 1913. Woodcut (actual
size)

smaller ones together. The tool used also differs: instead of being
cut with a knife, the wood is engraved with a *graver*, also called a
burin. This is a small steel rod, of square or lozenge section, with its
point sharpened obliquely. It is almost identical with the tool used
in line-engraving (see p. 35), except that for wood-engraving the
handle is usually tilted at a slight angle to the blade. The handle is
held against the palm and the graver pushed before the hand,
directed by the thumb held near the point of the blade. In this way a
clear V-shaped incision is cut into the wood. Gravers of differing

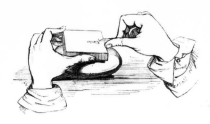

11 John Jackson *The wood-engraver's hands*, 1839. Wood-engraving (reduced). The block is held steady on a soft pad.

end-section (given names such as tint-tools, spit-sticks and scorpers) are used for making lines of special character, and a multiple tool for producing a series of parallel lines. Furthermore, sections of the block can be lowered with scrapers in order to make them print more lightly, as grey rather than black.

The method of printing is the same as for the woodcut. The use of the word 'engraving' in naming this process often causes confusion; it refers only to the method of cutting the block and does not imply that it is printed in the intaglio method (see pp. 30ff). Of course a very fine-lined wood-engraving *could* be inked and printed in intaglio, and this has indeed been done by Eric Gill and others. But this is hardly ever tried for the simple reason that the enormous pressure of an intaglio press would probably crack the block.

Because the wood-engraver is incising lines rather than cutting away wood to leave lines exposed, he is capable of work of much greater detail than the woodcutter. The trained reproductive wood-engraver of the nineteenth century was capable of cutting a fine mesh of lines which printed with an effect very similar to that of an area of watercolour wash (in fact a sort of primitive half-tone screen): this enabled the designer actually to make a wash rather than a line drawing on the block, something which would have been quite beyond the ability of a woodcutter to cut. Although the typical wood-engraving looks completely different from a woodcut, there is a middle ground where the two techniques can be used to similar effect and the visible distinction more or less collapses (see **14** and **15**).

Historical Wood-engraving grew out of the European woodcut tradition. After 1600, when woodcut had been largely abandoned for book illustration, it was still often used in a minor way for vignettes and tail-pieces. The best-known French cutter of such decorative ornaments was J. B. M. Papillon who published the first historical treatise on the woodcut in 1766. In England the Oxford

12,13 *below* Edward Calvert *The return home*, 1830. Wood-engraving (actual size) and the original block from which it was printed (*below right*). Since 1830, the letters at the bottom have been cut away.

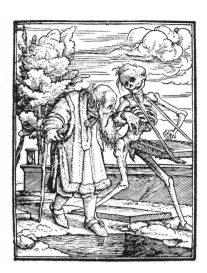

14 Hans Lützelburger after Hans Holbein *Death and the old man* (from the *Dance of Death*), *c.* 1522/6. Woodcut (actual size).

15 Luke Clennell after Thomas Stothard *Nymphs* (illustration to Samuel Rogers' *Poems*), 1810. Wood-engraving (actual size). This and **14** show how woodcut and wood-engraving can be used to almost indistinguishably similar effect.

University Press was already using end-grain engraving on boxwood for initial letters in the late seventeenth century. Thomas Bewick of Newcastle (1753–1828), usually considered the founder of wood-engraving, was the first to realize its full potentialities in the beautiful small vignettes of birds, animals and landscapes with which he illustrated the books he himself had written. His success was due to his own artistic genius, but a technical pre-requisite was the eighteenth-century development of smoother papers; work of such finesse could not have been printed on the old coarse papers.

Bewick's techniques were brought to London by his pupils such as John Jackson and Luke Clennell, who is famous for his facsimile renderings of the pen and ink illustrations by Stothard for Samuel Rogers' *Poems*. For the first thirty years of the nineteenth century the medium was mainly employed for similar high-quality book illustration. The most surprising and beautiful prints however were the seventeen wood-engravings made by William Blake to illustrate Thornton's school book *The Pastorals of Virgil* (1821), which inspired the few exquisite prints by his disciple Edward Calvert. They remained otherwise unnoticed at the time but have exercised a greater artistic influence during this century than any other of Blake's works.

The period of wood-engraving's widest use and greatest significance however only began after 1830 with the great expansion of journalism and book publishing brought about by the increase of popular education and the technical revolution of steam-powered printing presses. For works published in editions of many tens of thousands, wood-engraving was the only process of illustration available which could combine cheapness with abundance of detail. Thus in Europe and America an entire industry was created of engravers who could rapidly translate a drawing or a photograph into a network of lines on a block of wood. Regular systems of hatching were evolved so that if a large illustration was required in a hurry, the composite block could be taken apart and apportioned among a number of engravers. This encouraged the formation of large workshops, the most famous of which were those of the Dalziel brothers and Swain. Various technological inventions helped the industry: from the 1830s blocks could be multiplied and the danger of damage avoided by printing from stereotypes, and later from electrotypes (see glossary), while in the 1860s it became usual to print a photograph directly onto the block and thus eliminate the need to make a drawing.

Although much of this work was humble and is now of little interest, the technique was also used in many of the masterpieces of Victorian book illustration. The forerunner of the famous flourishing of the illustrated book in the 'Sixties' was Moxon's 1857 edition of Tennyson on which most of the Pre-Raphaelites collaborated. Although Millais, Holman Hunt and Rossetti only occasionally

designed illustrations, some fine Victorian artists such as Birket Foster and Boyd Houghton did little else in their careers.

Work of similar standard can be found abroad. The first such masterpiece in France was Curmer's 1839 edition of *Paul et Virginie*, illustrated by Johannot and Meissonier, and it was followed by the numerous books illustrated by such designers as Honoré Daumier and Gustave Doré. The finest work in Germany was Kugler's *Geschichte Friedrichs des Grossen* (1839–42) with illustrations by Adolf Menzel. In 1849, after the Berlin revolution, Rethel produced a remarkable series entitled *Auch ein Totentanz*, exceptional for the nineteenth century in looking like woodcuts rather than wood-engravings. In the United States a brilliant group of wood-engravers was mainly employed on magazines like *Harper's Bazaar* and *Scribner's*, and at the end of the century Timothy Cole gained a world-wide reputation for his reproductions of Old Master paintings.

Throughout the western world the flood of publications illustrated with wood-engravings increased steadily during the nineteenth century, but the whole flourishing industry was dead within a decade of the introduction of photomechanically produced blocks in the mid-1880s. The most advanced designers of the 1890s, such as Aubrey Beardsley, made their black and white drawings not for the wood-engraver but for the process engraver to turn directly into a line block.

Although this was the end of the reproductive wood-engraving, the twentieth century has seen a remarkable revival of the medium in the hands of artists who have taken up where Bewick and Blake left off, and have exploited the intimate scale and detail which it allows to produce original prints to their own designs. These artists have been closely linked with and patronized by the private press movement, beginning with Burne-Jones' collaboration with William Morris in the 1890s in such works as the Kelmscott *Chaucer*. Their lead was followed by Ricketts and Shannon at their Vale Press and by Lucien Pissarro at his Eragny Press, and the fashion spread to Europe and America. The heyday of this movement was between the two World Wars, but it continues to have a little-publicized following, especially in Britain.

Metalcut and Relief Etching

Various other relief printing methods which used a metal plate rather than a wooden block have found popularity at certain periods, and they can be grouped together in this section.

The most frequent method was to cut the plate to the same effect as wood. This was often employed from the fifteenth to the nineteenth centuries for frequently re-used decorative elements, such as borders and title-pages in book illustration. The advantage of metal over wood is that it is much less liable to damage and wear,

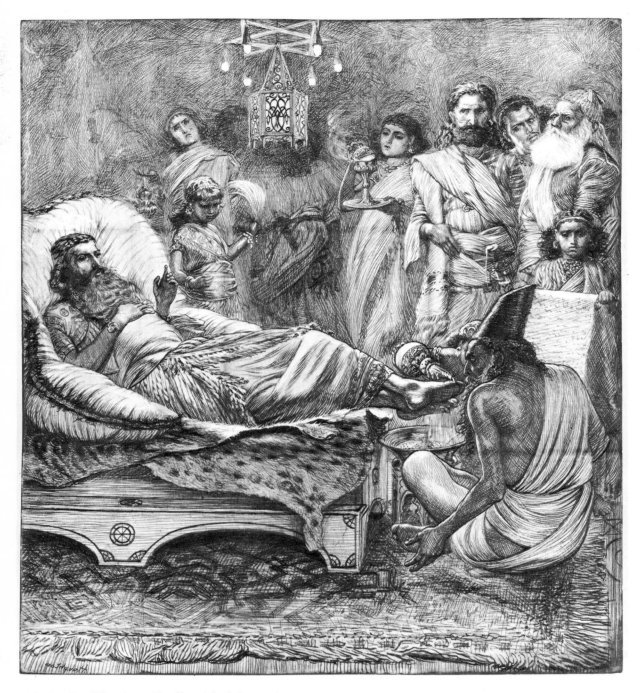

16 Arthur Boyd Houghton *The Chronicles being read to
the King*, *c.* 1861/2. Drawing in pencil on a block of
boxwood (slightly reduced). This drawing was preserved
because the design was photographically transferred to
another block.

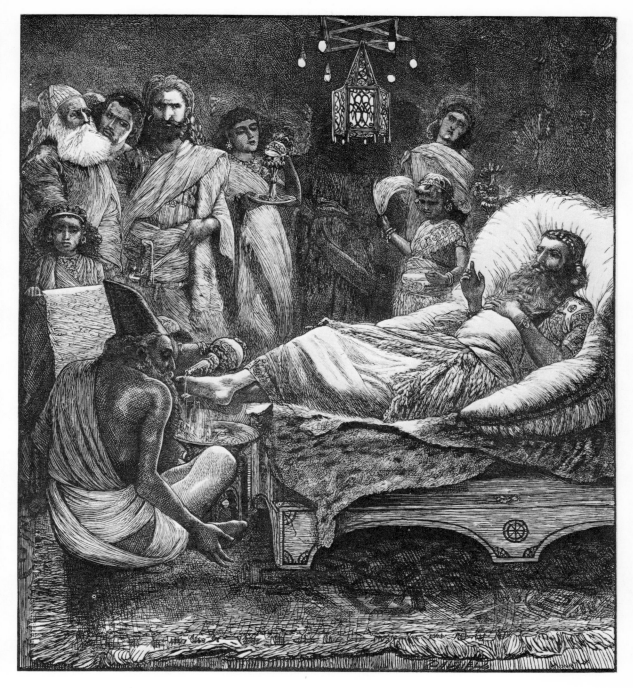

17 Dalziel Brothers. Wood-engraving after **16** (slightly reduced). Houghton has drawn with unusual precision on the block and the engraver has followed him closely. Note how the design had to be drawn in reverse; the King, for example, is left-handed.

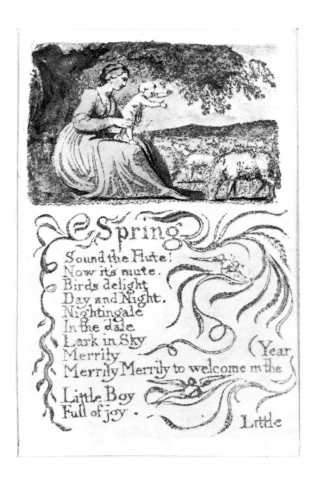

18 William Blake *Spring*, 1789. Relief etching with hand-colouring (actual size).

and sometimes it is found even before the nineteenth century that a metal block was cast from a wooden original. In this first type of metalcut the metal is simply an alternative medium to wood, and from an inspection of a print it can be almost impossible to tell from which sort of block it was printed.

In the fifteenth century a more distinctive use of metalcut was invented in order to create a particular decorative effect. The plate was first engraved with the outline of the subject, and then the large areas of unrelieved black were broken up using punches and stamps. These prints in the 'dotted manner', or *'manière criblée'*, were produced in the second half of the century in Germany and France, and are often, even if barbaric in effect, rather beautiful. It is likely that they were produced by professional metalworkers rather than woodcutters. The process was also used in France in the years around 1500 for a series of splendidly decorated Books of Hours, and lived on well into the sixteenth century as a method of producing initial letters.

With the exception of a few metalcut book illustrations and landscapes made by Elisha Kirkall in the 1720s, the next known use

of a relief-printed metal plate (although in this case etched rather than cut) was made by William Blake in the famous series of illuminated books which he wrote and printed between 1788 and 1820. Although the details are still obscure, it seems likely that he wrote his text and drew the accompanying illustrations on paper with some sort of etching ground. The paper was then pressed against a copper plate and the ground transferred; in this way the design and writing were reversed so that they would come out the right way round in printing. The copper was then immersed in acid so that the background was etched away, leaving the design in relief. The plates could finally be inked and printed from the relief surface. Individual pages were either printed in colours or hand-coloured by Blake or his wife, each of the rare copies of the various books showing sometimes surprising variations in colour. The process was extraordinarily laborious but the results are superb, the text and illustration having a unity unprecedented in the history of the printed book.

19 Anonymous, *Calvary*, German, *c.* 1450/60. Metalcut in the dotted manner, coloured by hand (greatly reduced).

Intaglio Printing Processes

The class of intaglio prints is defined by its particular technique of printing from a metal plate one or two millimetres thick, usually of copper but occasionally of iron, steel or (more recently) zinc. Incisions are made in the plate in various ways, and it is the different techniques used to make these marks that distinguish the various processes of the intaglio family, of which the most common are engraving and etching. But in whatever way the lines are opened in the plate, the method of printing is the same.

Unlike woodcuts and wood-engravings which are inked so that the ink lies on the uppermost surface, intaglio plates are wiped clean so that the ink is left only in the incisions. They are then printed under great pressure so that the paper is forced into the grooves to pull out the ink.

The plate is first warmed on a hot-plate and covered with printing ink applied with a dabber; the ink has to be thoroughly worked in so that it penetrates and fills all the lines in the plate. The plate is then carefully wiped with muslin to clean all the ink off the surface, but without going so far as to drag any out of the lines. This is a laborious and skilled process; the printer has to use a series of muslins, each one cleaner than the last, before the surface is sufficiently clean and ready to print. An intaglio press works on a similar principle to the old-fashioned clothes-mangle: a sliding bed passes horizontally between two rollers as the operator turns the wheel. The inked plate is placed face upwards on the bed of the press, a sheet of dampened paper is positioned on top of it, and several specially resilient blankets (to even out the pressure) are laid over both. As the bed passes between the rollers, the paper is forced into the grooves in the plate and drags out the ink. Finally the sheet of paper is hung up to dry. Before another impression can be printed the plate must be re-inked and re-wiped. Even the most skilled printer will take several minutes to print each impression, and for this reason intaglio is a more expensive printing process than relief, where inking is simply done with a roller.

The great pressure of an intaglio press produces the most obvious feature of intaglio prints, the *plate-mark*. This is the line of indentation in the paper where it has been pressed around the edges of the plate. The way the ink lies on the paper also distinguishes an intaglio print; in all other printing processes it lies flat, but in intaglio it stands out from the paper as ridges, perceptible to a delicate touch with the finger tip. (This is seen at its most extreme on an engraved letter head or visiting card). Repeated wipings and the pressure between the rollers flatten a copper plate very quickly, and as it wears the quality of each impression deteriorates. It is therefore important, where possible, to see an early impression of any intaglio print.

The printer is the unsung hero of all the printing processes, but

he plays a particularly important part in intaglio printing; the difference between a well and badly printed impression from the same plate can be astonishing. In general, the more densely worked the plate the more complicated is the inking. The most difficult are mezzotints, and, in the case of the very large ones by John Martin, it is recorded that the printer could manage only eight to ten impressions a day. A good printer could also nurse a plate into producing many more impressions before wearing it out, and the question of who should be the printer is often mentioned in eighteenth-century contracts between artist or publisher and engraver. Occasionally the printer's skill was acknowledged by the addition of his name to the lettering on the plate.

By deliberately leaving films of ink on the surface ('surface-tone') a printer can also create different effects from the one plate. Etchings, because they were often intended as works of art in their own right and were frequently printed by the artist himself, often exhibit such refinements of inking. The earliest such attempts seem to have been made by Dürer, but the first master of the art was Rembrandt, who occasionally completely transformed the appearance of his prints by these means. In the so-called 'etching revival' of the nineteenth century this was much admired, and

20 Abraham Bosse *Intaglio printing*, 1642. Etching (greatly reduced). The man at the back is inking the plate; his colleague is completing the wiping with the palm of his hand. The printer has positioned the plate on the bed of the press, covered it with the paper and blankets and is now turning the wheel to force it between the rollers. In the background, printed sheets are being hung up to dry.

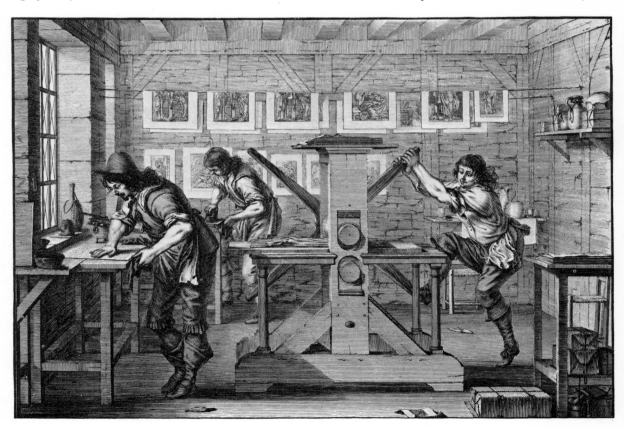

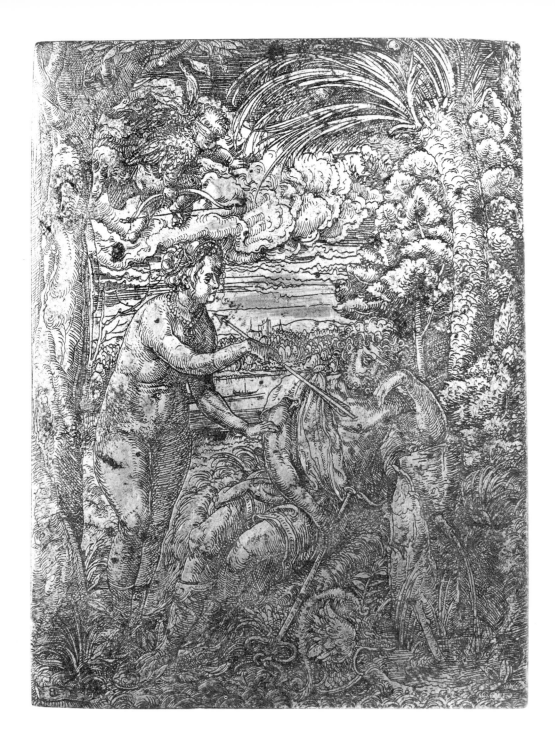

21 Hans Burgkmair *Venus and Mercury*, *c*. 1520. The etched steel plate (actual size).

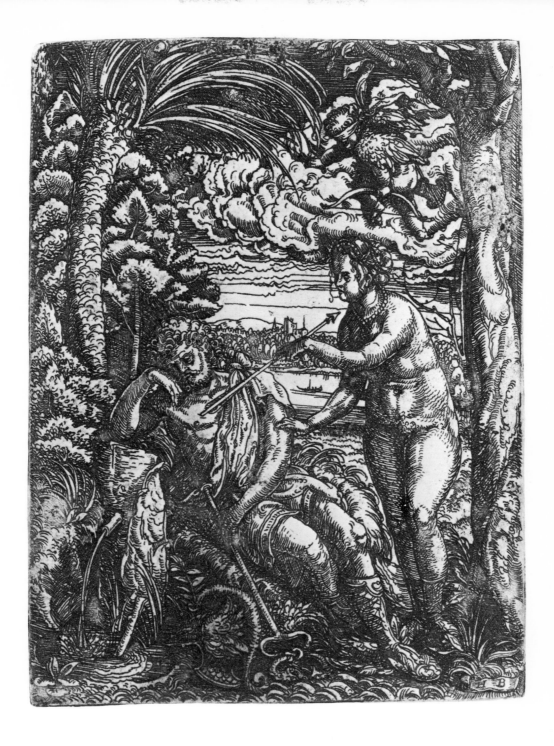

22 Impression from **21** (actual size). When this impression was printed,
the rust marks were not yet too obtrusive.

23,24 Maxime Lalanne *Copy after Claude* (detail), 1866. Etching (enlarged two times). Two impressions from the same plate. The first (*right*) has been clean-wiped; the second (*far right*) has been printed with heavy *retroussage*, which has dragged some of the ink out of the lines.

'artistic' printing of etchings became standard; the best printers, such as Delâtre in Paris and Goulding in London, acquired a celebrity as great as that of any etcher of the period. Another commonly adopted practice was *retroussage*. A fine muslin was passed lightly over the already inked and wiped plate in order to pull some of the ink out of the lines, which in this way lost some of their sharpness of definition (see **23** and **24**). A further consequence of the new emphasis on printing was the *bon à tirer* (good for printing) proof; the artist would approve an impression as the standard for the printer to follow when printing the main edition. These refinements, which were too often used simply to mask poor draughtsmanship and which were mocked by Walter Sickert, who thought that any good etching should be wiped as clean as a visiting card, have now largely been abandoned.

Another element, important in all printing but particularly so with intaglio, is the choice of paper, which can radically affect the appearance of a print. Although in the fifteenth and sixteenth centuries illustrations in books had been occasionally printed on vellum or blue paper and a few single sheet prints on silk, it was not until the seventeenth century that artists explored this field with any enthusiasm. Hercules Segers led the way by sometimes printing on cloth, but the greatest figure was (again) Rembrandt who experimented with vellum, a variety of imported yellowish Japanese papers, a thin 'Chinese' paper and a rough oatmeal paper. Although some of his contemporaries such as Everdingen and Backhuysen also used Japanese papers, his lead was only followed again in the nineteenth century by artists such as Whistler, who amassed a large collection of old and exotic papers. This was to a large extent a reaction against the poor quality of the nineteenth-

century machine-made papers, and in recent years, especially in America, artists have again begun to take enormous trouble over the choice of hand-made papers. One product of this interest in paper has been the creation in the early 1970s of a new art form – objects of hand-moulded paper formed from dyed paper pulp.

Engraving

Technique Engraving is the principal and oldest member of the class of intaglio processes. The tool used is a *burin*, also known as a *graver*; this has already been described in the section devoted to wood-engraving (p. 22). It is held in the palm of the hand, and pushed forward with the forefinger lying along the blade. In its passage it cuts a clean V-shaped groove; the curls of copper thrown up in front and at the sides of the furrow are cleaned away with a scraper. Mistaken incisions can be repaired by knocking up the copper from the back of the plate and smoothing down the surface with a scraper and burnisher before re-cutting the line.

Engraving is a highly skilled craft. It requires much practice to cut a regular, even groove, whether straight or curved, and a long apprenticeship to learn the various systems of laying parallel lines which give engraving its peculiar clarity and brilliance. Moreover it can be a very lengthy process; in the late eighteenth and early nineteenth centuries an engraver might spend years on a large plate. For these reasons it has rarely since the sixteenth century been handled by any except professional printmakers, who have usually been employed in making reproductions of drawings or paintings.

One advantage of engraving over other intaglio methods for this purpose was that so much copper was extracted from the plate by the V-shaped gouge that a plate did not quickly wear out in printing. This, however, ceased to be the case when a more minute and detailed style of engraving became popular in the eighteenth century. The engraver had no choice but to stand in attendance on the printer and rework vital areas as they became worn; nevertheless the maximum number of impressions obtainable did not exceed two to three thousand. In the 1810s the situation changed with the introduction of steel plates which could produce a virtually unlimited supply of impressions. Because steel is so difficult to engrave, the plates were usually etched, and so a typical 'steel engraving' will in fact consist entirely of etched lines laid in the regular manner of an engraving. A final upheaval took place with the invention of steel-facing (see glossary) in 1857. The engraver could again work on copper, but have the original sharpness of his design preserved under a thin coating of steel.

The only type of print likely to be confused with an engraving is an etching; the ways of distinguishing the two are described in the section on etching (p. 58). The use of a steel rather than a copper

25 Abraham Bosse *The burin and how to hold it*, 1645. Etching (reduced).

Overleaf
26 *left* Rembrandt *The Presentation in the Temple*, c. 1645. Etching with drypoint (actual size). This impression has been clean-wiped and printed on white paper.

27 *right* Another impression from the same plate as **26**. This impression has been printed with heavy surface tone on a yellowish Japanese paper. Rembrandt has deliberately left films of ink on parts of the plate in order to heighten the drama of the scene.

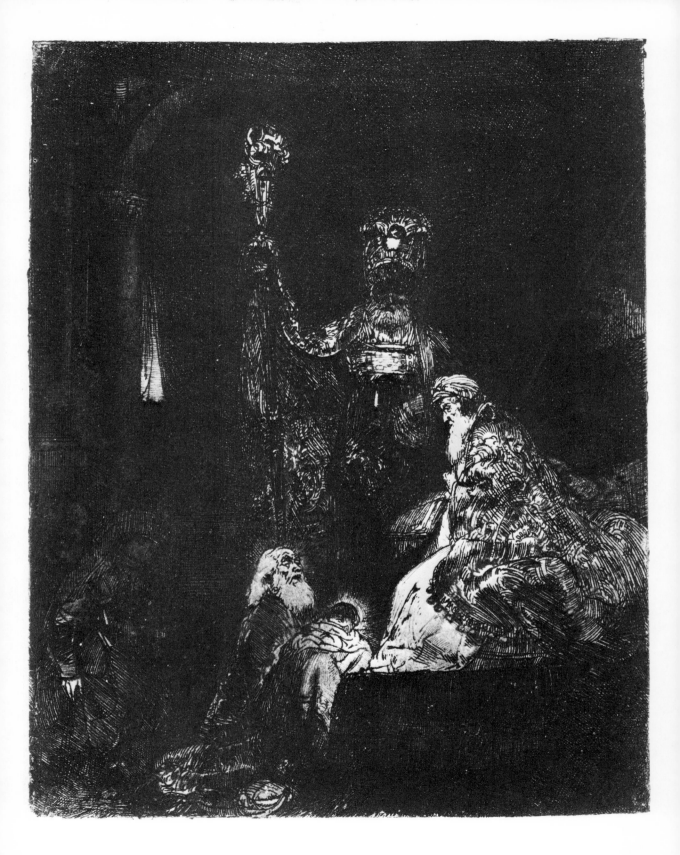

plate can often be spotted by the manner of engraving. Steel, being so hard, required the use of a fine line and closely massed parallels rather than broad, open and deep lines. It was therefore used mostly for small and highly detailed plates, many of which were intended as book illustrations.

NOTE: The word 'engraving' is often confusingly used as a generic term to cover *all* intaglio prints, not just those made with the burin. This usage is loose, but cannot exactly be called wrong because it is so well established. (One reason for this ambiguity is that 'engraver' is correctly used of all types of intaglio printmaker except the etcher.) In this book the word will invariably be used in its strict sense. Authors sometimes use the term 'line-engraving' as another way out of this difficulty. An even wider use of the term 'engraving' to cover *all* prints, however made, is sometimes found; it is for example implied in the title of A. M. Hind's *Guide to the Processes and Schools of Engraving*. This is even more confusing than the previous usage, and is best avoided completely.

Historical The history of engraving before 1800 is the history of perhaps as much as three-quarters of all European print production; this section cannot help being even more summary than the others.

The art of engraving or incising into metal reaches back into antiquity; it was used by the Greeks, Etruscans and Romans to decorate such metal objects as bronze mirror-backs, and flourished throughout the Middle Ages as a method of embellishing gold and silver. The idea of using engraved plates to make prints from did not occur before the fifteenth century, and probably began with the

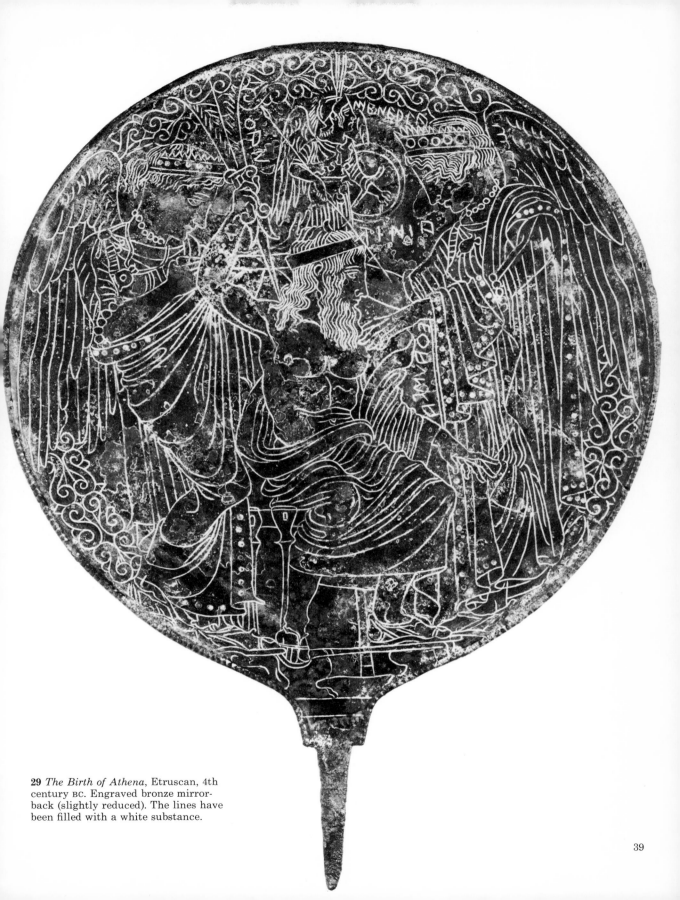

29 *The Birth of Athena*, Etruscan, 4th century BC. Engraved bronze mirror-back (slightly reduced). The lines have been filled with a white substance.

goldsmiths' desire to keep records of their designs. The credit for this invention belongs to the Germans, and the earliest impressions on paper were made in the 1430s, half a century later than the earliest woodcuts. For the next forty years engraved prints remained tied to the style of goldsmiths, the most important artists being the Master of the Playing Cards and the Master ES. Though most prints of this time have religious subjects, there can already be found secular interests in such things as folk legend, figures from everyday life, animals and ornamental designs, which cannot easily be paralleled in contemporary woodcuts. A new period opened in the 1470s when the medium was taken up by painters, of whom Martin Schongauer (*c*. 1450–91) and the Master LCz were the most distinguished. This development reached its highest point in the work of Albrecht Dürer (1471–1528), whose engravings are still regarded as the finest ever made. Dürer, like Schongauer, never regarded engraving (or indeed woodcut) as a minor art, and seems to have lavished more thought and care on these compositions than he did on any except a few paintings. Some of the great German sculptors of the period were also encouraged to turn their hand to this medium, and a few very rare and superb prints by Veit Stoss and Hans Leinberger survive.

The art of printing engravings was introduced into the area of the lower Rhine within a few years of its invention in the upper Rhine. The small group of early prints by artists such as the Master of the Gardens of Love (who derives his name from two prints which wonderfully preserve the atmosphere of Burgundian courtly dalliance) was followed by the splendid works of the Master FVB and the prolific Israhel van Meckenem (before 1450–*c*. 1503) who links the German and Netherlandish traditions. The Netherlandish equivalent to Dürer was the child prodigy Lucas van Leyden (? 1494–1533). Like Dürer, Lucas was a painter who put as much effort into his prints as into his paintings. The earliest prints are as remarkable for their unusual subject-matter as their beautiful technique, but his powers sadly declined in the 1520s when he began to imitate the manner of Marcantonio.

The Italian tradition developed independently of the Northern, but somewhat later. Vasari wrongly ascribed the invention of engraving to the Florentine goldsmith Maso Finiguerra (1426–64), but, although Maso is a well-documented figure, no prints have yet been attributed to him with any degree of confidence. The earliest surviving Italian prints were made in Florence probably in the late 1440s, and historians have divided the production of the period from about 1460 to 1490 into two styles, the 'fine' and the 'broad' manners, depending on the manner of working. Early Italian prints present a very different aspect to Northern ones; they are usually hatched with parallel lines, printed in a light brown ink, and show a distinct range of subjects, with astrological, mythological, poetical

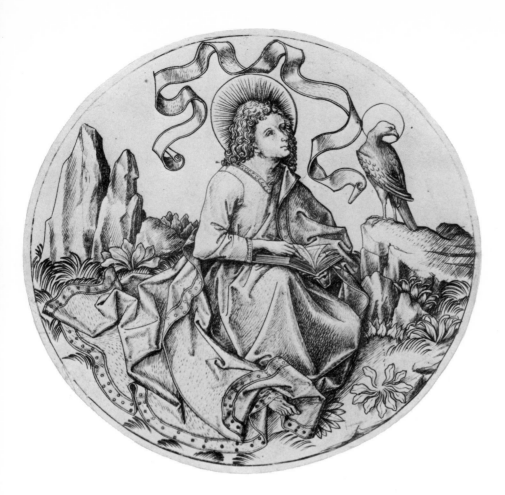

30 Masters ES *St John*, *c.* 1460/70.
Engraving (actual size).

31 Martin Schongauer *Lady holding a
shield with a unicorn*, *c.* 1480/90.
Engraving (actual size).

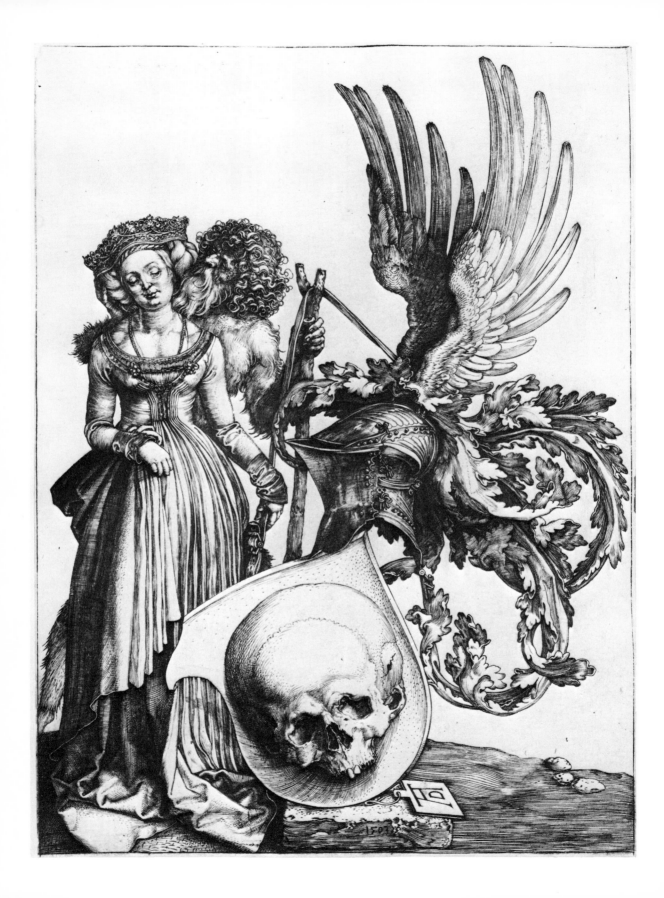

32 *left* Albrecht Dürer *Coat of arms with a skull*, 1503. Engraving (actual size). An example of Dürer's mature technique.

33 *above* Lucas van Leyden *The Temptation of Christ*, 1518. Engraving (actual size).

and other secular themes predominating. One minor group of round prints, known as 'Otto' prints after an eighteenth-century collector, was designed to decorate the lids of small boxes; another curious group called *nielli* is described in the glossary. Only one great Florentine painter is known to have personally engraved a plate. This was Antonio Pollaiuolo, whose single print, *The Battle of the Nudes*, stands out as one of the most ambitious and influential engravings ever made. Alessandro Botticelli is said by Vasari to have designed an illustrated *Inferno* of Dante (presumably the 1481 Landino edition) and to have supplied numerous further designs for others to engrave, but the details are still wrapped in obscurity. Outside Florence some notable prints were made in Ferrara, but the greatest figure was Andrea Mantegna (1431–1506), a native of Padua who spent most of his career at the court of Mantua. Seven prints are generally accepted as being from his own hand, while others are assigned to his studio. His technique was adapted from the Florentine broad manner, but his compositions had a dramatic power and formal inventiveness that exercised a widespread influence, especially north of the Alps. In Venice an independent tradition began with Jacopo de' Barbari, whose huge woodcut map of the city has already been mentioned, and continued with Giulio Campagnola, whose rare engravings, infused with the spirit of Giorgione, are described in the section on stipple.

The most significant figure of the period was Marcantonio Raimondi (c. 1480– after 1527). Beginning as a rather provincial engraver in Bologna, he moved to Venice in about 1506 and published engraved piracies of Dürer's woodcut series of *The Life of the Virgin*, which are said by Vasari to have been the motive for Dürer's second voyage to Italy. In 1510 he arrived in Rome, and it is his association with Raphael in the decade before Raphael's premature death in 1520 that established his reputation and set the pattern for the future development of engraving. Until this time the engraver, whether Italian or Northern, had usually produced prints of designs of his own devising. A precedent may be found in the school of Mantegna, but it was Raphael who first realized the potential of prints for broadcasting his new style. To this end he seems to have supplied Marcantonio (and Ugo da Carpi, his cutter of chiaroscuro woodcuts) with purpose-made drawings, taught him how to copy their system of regular cross-hatching and set him up with his factotum, il Baviera, to act as publisher. Thanks to Marcantonio's great technical skill, the suitability of engraving for reproductive purposes was decisively demonstrated, and it is the combination of designer, engraver and publisher that dominates the future history of the medium. It has been customary to deplore the fact that later engraving, as distinct from fifteenth-century work, was so largely reproductive, but the entire history of

34 Andrea Mantegna *The Virgin and Child*, late 1480s. Engraving (reduced).
The extraordinarily soft and crumbly lines that Mantegna sought in his
prints can be seen in this early impression, especially on the Virgin's face.

35 *left* Raphael *Venus and Cupid*, *c.* 1510/12. Drawing in metal point on pink prepared paper (actual size).

36 *right* Marcantonio Raimondi after Raphael *Venus and Cupid*, *c.* 1510/12. Engraving (actual size). An example of the close collaboration between the two artists; the print shows how Marcantonio adopted Raphael's system of shading and modelling volumes. Although the size and many details differ, it seems more probable that Marcantonio adapted this drawing rather than copied another (lost) more finished one.

Western art would have been quite different if engravings had not rapidly disseminated every stylistic innovation all around Europe.

None of this came to pass overnight. In Germany, Dürer had distinguished successors in the school of 'Little Masters', so named because of the small size of their plates. The best of these artists were the brothers Barthel and H. S. Beham, George Pencz and Heinrich Aldegrever; Albrecht Altdorfer too, in his engraved work, may be counted as a member of this group. In the Netherlands Lucas van Leyden was followed by Dirk Vellert and Frans Crabbe. But both these masters make as much use of etching as they do of engraving, and the middle of the century sees a parting of the ways of the two techniques. Henceforth the artist who is making an original design in intaglio will almost invariably use etching, while engraving becomes the preserve of the reproductive specialist. The causes of this division are discussed in the section on etching, but an important proviso must be made at this point that the reproductive engraver often combined etching with engraving, and that it is by no means unknown for a reproductive 'engraving' to be in fact entirely etched. For this reason it is impossible to make a hard and fast distinction between the history of engraving and that of etching.

Marcantonio founded a whole school of engravers scarcely less skilful than himself: his colleague Agostino Veneziano, Jacopo Caraglio who worked for Parmigianino, and the various members of the Ghisi family who were closely connected with Giulio Romano and his school in Mantua. The successor to il Baviera as the principal Roman print publisher was Antonio Salamanca, who entered into partnership in 1553 with Antonio Lafréry, an immigrant from Besançon. Lafréry's prints were predominantly views of the ancient ruins meant for the tourist market; this tradition continued uninterruptedly in Rome up to the time of Piranesi and even beyond. Lafréry employed a number of craftsmen, many of whom did not bother to sign their work; plates were held in stock, a published catalogue (of 1572) informed customers what was available, prints were run off as ordered and plates were constantly reworked or re-engraved when worn out.

This functional attitude, and the evident profits to be made, impressed Hieronymus Cock on his visit to Rome in 1546, and when he returned to Antwerp in 1548 he hastened to introduce the system to the North. A different market needed different products, and Cock showed great flair in commissioning series of drawings from the leading artists of the period (notably Pieter Bruegel the elder) to be turned into prints by his employees, to train whom he had to entice Giorgio Ghisi from Mantua. The most popular subjects were scenes from the Bible, allegories of the virtues and vices, landscapes and portraits. Many of these were bound into books or were intended as book illustrations in the first place, and,

as engraving ousted woodcut as the preferred method of illustration, this market became increasingly important. Cock was followed by Philip Galle and his dynasty, by Adriaen Collaert, Pieter de Jode, the three Wierix brothers and the Passe dynasty, and in the second half of the sixteenth century an unprecedented flood of engravings poured from Antwerp over the rest of Europe.

Other engravers took their skills abroad, and by the early years of the seventeenth century dynasties of printmakers of Antwerp origin had established themselves in most of the major cities of Europe. The most successful were the three Sadelers, who left Antwerp, one to become court engraver to Rudolf II in Prague, the other two to settle in Munich and Venice; Theodor de Bry moved to Frankfurt where his business was continued by the Merian family; Domenicus Custos married into the Kilian family in Augsburg; while Thomas de Leu introduced the Flemish manner to Paris. Cornelis Cort founded no dynasty, but had a great influence; after his move from Cock's shop to Italy in 1565, many of the leading painters of the time, especially Titian and Girolamo Muziano, employed him to engrave their compositions, and many Italian engravers such as Agostino Carracci modelled their manner on his.

These professional engravers were enormously prolific (the Wierix brothers alone produced over 2,000 prints) and highly competent, but their choice of subject-matter was restricted and their manner tended to be dry. Neither of these strictures could be applied to Hendrik Goltzius of Haarlem (1558–1617), whose technical innovations had a decisive influence on the seventeenth-century manner of engraving. Goltzius began his career as a printmaker, and many of his engravings are after his own drawings. Trained by a pupil of one of Cock's engravers, he soon developed a virtuoso technique of modelling form with systems of parallel curving arcs, which swelled in thickness towards the centre; when allied to the bombastic mannerist style of composition which he had learnt from Bartholomeus Spranger, this produced prints of unparalleled visual splendour. After Goltzius abandoned engraving in favour of painting in 1599, he was succeeded by his scarcely less brilliant pupils, Jacob Matham, Jan Muller and Jan Saenredam. In Italy, the French engraver Claude Mellan used the swelling line technique to produce an extraordinary *tour de force*, the *Veil of St Veronica*, represented in one continuous spiral line beginning in the centre of Christ's nose.

In Antwerp Rubens had begun to have his compositions reproduced by local engravers such as Cornelis Galle in 1610; dissatisfied with the results he first turned to engravers of Goltzius' school in the United Provinces, but soon decided to train his own school instead. The first of these engravers was Lucas Vorsterman who, working between about 1618 and 1622, established a style based on Goltzius' but more painterly in effect and less tied to mannerist

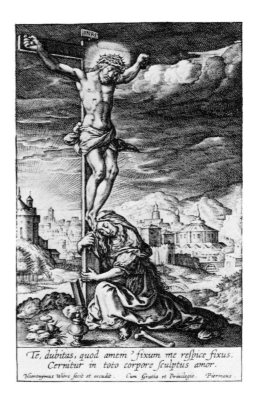

Te, dubitas, quod amem? fixum me respice fixus.
Cernitur in toto corpore sculptus amor.
Hieronymus Wierx fecit et excudit. Cum Gratia et Privilegio. Piermans.

37 Hieronymus Wierix *Mary Magdalene at the foot of the Cross,* 1590s (?). Engraving (actual size).

formulae. This was followed by the other chief members of the Rubens workshop, Paulus Pontius and the brothers Boetius and Schelte Adams Bolswert; the first two specialized in figure compositions and portraits, the latter is best known for his splendid landscapes.

One isolated engraver devised a quite independent style to meet a particular requirement. This was Hendrik Goudt, an amateur later created a Count, who made seven engravings after the paintings of his friend Adam Elsheimer between 1608 and 1613. To capture their concern with the contrast of light and dark, Goudt closely worked his plates with a mass of straight parallel lines; these printed a vibrant black from which the unworked areas of light stood out in sharp contrast. The only engraver successfully to follow this style was Jan van de Velde, who used it in a few prints either after his own designs or those of Willem Buytewech.

At this point, towards the middle of the seventeenth century, as a consequence of the prolonged Spanish-Dutch wars and the new prosperity in France, the centre of European printmaking shifted decisively from the Netherlands to Paris. Although in the sixteenth century France could only boast one important engraver, the royal goldsmith Jean Duvet, it dominated printmaking from about 1640 until the Revolution of 1789. Two main traditions can be distinguished in the seventeenth century. The first is reproductive;

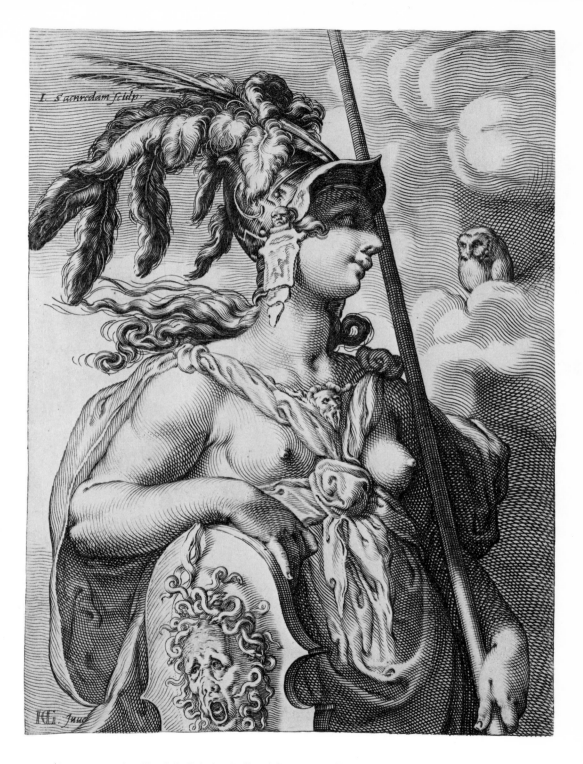

38 Jan Saenredam after Hendrik Goltzius *Pallas Athene*, 1590s. Engraving
(actual size). A characteristic Mannerist engraving. The remarkable stylistic
revolution in Dutch seventeenth-century art is shown by the fact that Jan's
son, Pieter, was the famous painter of church interiors.

39 Jan van de Velde *Sun-set, c.* 1620. Engraving (actual size).

but, whereas earlier reproductive prints had, as often as not, been reproducing drawings made expressly to be engraved, the French prints were almost invariably after paintings by the leading artists of the day. One feature of this was the forging of close links between an artist and his engravers. The first to do so was Simon Vouet, whose two main engravers became his sons-in-law; he was followed by Philippe de Champaigne, Nicolas Poussin, Charles Le Brun, Hyacinthe Rigaud and in the eighteenth century Jean-Baptiste Greuze. Another feature was the considerable use made of etching to lay in foundations which were then strengthened or completed by burin work; typically landscapes and drapery were etched, while faces and flesh were engraved.

The second tradition was of portrait prints; its founder was Robert Nanteuil (1623–78), who engraved with a classic restraint and surety of judgement, usually after his own chalk drawings. His successors, among whom were such wonderful engravers as Antoine Masson, Gérard Edelinck and the three Drevet, often worked after paintings as well, but maintained his purism by refusing to admit any etching into their prints. This began to break down in the eighteenth century. Although the tradition of the large portrait continued for engravers' *morceaux de réception* for the Académie Royale, some engravers such as Étienne Ficquet began to specialize in minutely worked small heads, while the great series of medallions after the drawings of C. N. Cochin fils are entirely etched.

In the eighteenth century a third tradition was invented, which is perhaps France's most original contribution to the art of the print. This is of the highly finished engraving, usually of some *'galant'* subject, designed to be framed and hung on the wall. These seem to have had their origin in the success of the *Recueil Julienne*, the two huge volumes of engravings after Watteau's paintings, published posthumously in 1736. Many were after paintings by the foremost artists of the time such as Boucher and Fragonard; as many again were engraved from specially-made gouaches drawn by minor masters like Pierre-Antoine Baudouin and the Swede Nicolas Lavreince. The engraving was usually done over an etched foundation, which was often regarded as a work of art in its own right, and frequently specialists in the two arts would collaborate over the print (cf. **45-48**). It is necessary to stress the superlative skill shown in these prints as they are now unjustly neglected. The French system of art education gave the same training to the printmaker as to the painter; all were therefore skilled draughtsmen and with the additional technical apprenticeship in such shops as that of Le Bas, the French engravers stood unequalled in Europe.

During the two centuries of French domination print production in the rest of Europe was far from insignificant. The strongest challenge came from England, a country whose engravers (although not the mezzotinters) had remained provincial until the eighteenth century. The first important figure was William Hogarth (1697–1764), who was probably the first artist to make paintings specifically to be engraved. He had the more conventional subjects engraved in the usual manner of the period, but in his most original moralizing works intentionally used a simplified technique both to reinforce the impact of his message and to reduce the price of the individual impression. The main line of reproductive engravers was trained by the Frenchmen who came over to work for publishers in the 1730s. The first Englishman to achieve an international reputation was William Woollett (1735–85), whose own abilities were decisively boosted by the flair of his publisher, John Boydell. Boydell was the first of the great publishers who dominate the closing period of the history of the reproductive engraving; it was his boast at the end of his career that he had turned Britain into a net exporter of prints. His fortune (and position as Lord Mayor of London) was largely built on popular stipples and topographical prints, but he earned a larger place in the history of art by commissioning huge 'history' paintings from British artists to be engraved for such schemes as his illustrated Shakespeare.

William Blake was apprenticed into the tradition of reproductive engraving, and many commissioned plates prove his mastery of it. However, when in later life he wished to make engravings from his own designs, he threw over this system in favour of an entirely

Guillaume Cardinal Dubois, Archevesque
Duc de Cambray, Prince du S.t Empire, Premier Ministre.
Né le 6 Septembre 1656. mort le 10 Aoust 1723.

original manner composed of brilliant, flowing lines. This is seen at
its best in the twenty-one illustrations to the *Book of Job* (1826) and
the seven plates for Dante left unfinished at his death.

The end of the eighteenth century saw one remarkable develop-
ment which reached across Europe. The rise of a breed of rich art
lovers who required high-quality reproductions of famous paint-
ings combined with the neo-classical love of strict regularity to
give engraving an unassailable prestige against etching; as a result
reproductive engravers abandoned the practice of preparatory
etching, and devoted years to the laborious tooling of one immacu-
late plate. The most famous of these virtuosi was the Neapolitan
Raphael Morghen (1758–1833), but the most impressive was the
Frenchman Charles Bervic (1756–1822) who only completed six-
teen plates in his whole career. Their new system, known from its
most obvious characteristic the 'dot and lozenge', which was
developed by Jean Georges Wille (1715–1808), a German living in
Paris, became the approved method for instruction in the numerous
academies of engraving which were then springing up all over
Europe. It survived in them until the end of the nineteenth century,
and is responsible for the unfair contempt in which the craft of the
reproductive engraver is still held.

Nineteenth-century engravings usually belong to one of two
classes. The aristocrats of the profession devoted years to huge
plates after the popular paintings of the day. These prints sold in
large numbers at very high prices, and by the mid-century it was

42 Charles Bervic after Jean-Baptiste Regnault *The education of Achilles* (detail), 1798. Engraving with some etching (actual size). An example of the 'dot-and-lozenge' reproductive engraving; only the background is etched.

usual, at least in Britain, for an artist to earn more from the sale of a painting's copyright than from the painting itself. At the other end of the scale in size, engravers were employed on book illustrations. Although the mass market was the province of wood-engraving, there was a large demand for small, exquisitely worked engravings for illustrated annuals, keepsakes and suchlike. The best such prints were the various series of views of Britain and the Continent which were engraved after the drawings and under the supervision of J. M. W. Turner. From the 1810s such prints were often engraved or etched on steel plates, but the invention of steel-facing in 1857 made this unnecessary.

From the mid-nineteenth century the revived fashion for etching challenged the engraver's supremacy by popularizing a new class of reproductive etching, but it was the perfection of photomechanical techniques in the 1880s which put a quick and inglorious end to an ancient profession. In the twentieth century a few artists, mostly working in Paris and influenced by the example of S. W. Hayter, have revived the burin as a method of original rather than reproductive printmaking, but it has found no widespread popularity.

Etching

Technique Etching is the most important intaglio technique after engraving. Its essential principle is that the metal of the plate is eaten into by acid rather than cut out with a tool as in engraving. The plate is coated with a ground impervious to acid through which

the artist draws so as to expose the metal. The whole plate is then immersed in acid until the lines are sufficiently bitten. Finally the ground is removed and the plate inked and printed in the usual intaglio way, (see pp. 30–34).

Such is a summary of the process. The various stages may now be described with greater elaboration. The plates are usually copper or zinc, although various other metals have been used. Etching grounds are composed of various waxes, gums and resins; the old handbooks provide various recipes, but the only essential requirement is that the ground be soft enough to be drawn through, yet remain impervious to acid. The plate is warmed and the melted ground laid evenly over the surface either with a dabber (a cloth-covered pad filled with ground) or a roller. The ground is often darkened ('smoked') with a bunch of lighted tapers so that the lines drawn with the etching needle (a simple metal point) can be more easily seen as shining exposed metal.

The act of drawing is similar to putting pen to paper, but the medium does impose certain restrictions. It is impossible to wipe and print a plate so bitten as to leave pools of ink, so the artist cannot expose areas of copper wider than a thick line. Nor can he draw lines too close together because the acid will bite under the remaining ground. Any collapse of an etching ground will allow the acid to attack the plate indiscriminately; this is known as 'foul-biting'.

To bite a plate in an acid bath calls for experience, as the etcher has to judge the strength of whatever type of acid is used (which varies according to the metal) and how long to leave the plate in the bath, which can vary from minutes to hours. To ensure an even

43 de Fehrt *An etching workshop*, 1767. Etching (reduced). The activities depicted are (from right to left): laying the etching ground; knocking up a plate from the back to eliminate an error; smoking the grounded plate; etching the plate in an acid bath; drawing on the plate using a mirror to reverse the image; two other methods of etching the plate – either pouring acid or running it up and down over the surface; an engraver completing an etched plate with burin work. The large screens are used to diffuse the light coming through the window.

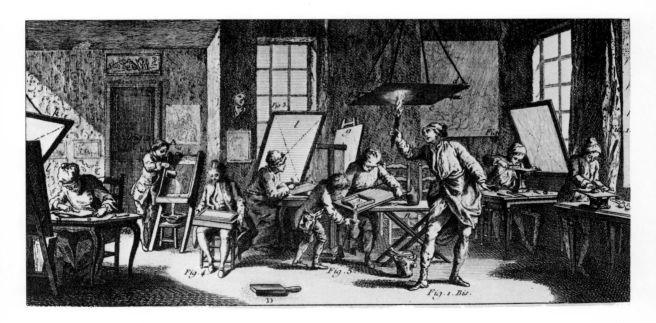

biting the bubbles that form on the plate have to be brushed away with a feather. The biting can be completed in one operation, but if lines of varying depth are required the plate is removed from the bath when the lightest lines are bitten. The etcher varnishes these over ('stopping out') and puts the plate back for a second biting. This process can be repeated as often as is necessary. Another method of graduating the depth of biting was used by Whistler in his later prints. By brushing acid directly onto the plate with a feather he produced the effect of a vignette which fades away at the edges.

At any stage the ground can be taken off a plate in order to print a proof to check progress. In these cases a second ground can be laid, but this has to be transparent in order to allow the etcher to see his earlier working. It is also possible to re-lay a ground very delicately so as to leave all but the lightest lines uncovered; this was sometimes done to strengthen the lines as they wore down during the course of a plate's publication.

Although etching is the most complicated of the intaglio processes to describe, it is the easiest for the amateur to try; he simply has to draw lines on a waxy surface, while the hard work of cutting the copper is done by the acid. The biting of the plate is more complicated, but this, like the printing, can be, and very often has been, handed over to a professional. For these reasons, etching has always been the preferred medium of non-professional printmakers, and in particular of artists who are primarily painters or draughtsmen. It is however extremely unpredictable, for it is never clear how the impression will come out until a proof is actually printed. This has alternately delighted and exasperated artists. Samuel Palmer wrote that etching had 'something of the excitement of gambling, without its guilt and its ruin'. Jasper Johns has put it differently: 'Within the short unit of an etching line there are fantastic things happening in the black ink, and none of those things are what one had in mind.'

An etched line is usually easy to distinguish from an engraved one. Because the ground can be drawn on with little effort, an etched line usually exhibits a much greater freedom than is possible for the engraver who must laboriously plough through the copper. The etched line can also be distinguished by its blunt rounded ends, whereas burin and drypoint lines taper into a point as the needle comes to the surface of the copper. Under a magnifying glass an etched line will be seen to be irregular in outline because the acid bites unevenly. Furthermore, the acid makes a rounded cavity, not an angular cut as does a burin, so that the ink lies on the surface in a mound rather than a sharply defined ridge, with a consequently less brilliant effect. Nevertheless it must be admitted that there are cases where it is very difficult to distinguish between the two processes. This is particularly acute in

44 John Sell Cotman *Castle at Dieppe*, 1822. Etching (greatly reduced). The tonal variations in this print are achieved entirely by laying series of short parallel lines at varying intervals, and etching them to different depths by stopping out.

the sixteenth century when some artists were drawing with the etching needle in exactly the same way as they were handling a burin, and when the two techniques were often combined on the one plate.

Etching has commonly been used in combination with drypoint and aquatint. This is discussed in the following sections.

Historical Etching was invented as a method of decorating armour, and was already known in the fourteenth century. This sort of decoration involved painting the design in resist and then etching away the background in order to leave the design standing out in relief. Since such a design cannot be printed in intaglio, it is not perhaps surprising that the idea of etching plates in order to print from them did not occur until some seventy years after the invention of printing from engraved plates. The earliest dated etching, of 1513, is by Urs Graf and only a few etchings are likely to have preceded it. In the first decades of the sixteenth century various artists experimented with the new technique, from Daniel Hopfer of Augsburg, who occasionally practised as an armourer, to Albrecht Dürer, who produced six etchings between 1515 and 1518. In the Netherlands Lucas van Leyden, Dirk Vellert and others used etching merely as a less laborious method of achieving the effect of engraving; when, as sometimes happened, the two techniques are combined on the one plate, they can be very hard to distinguish.

Early etchings often have a somewhat experimental character, and it took many years in Northern Europe for the medium to develop its own traditions. One reason for this is that early

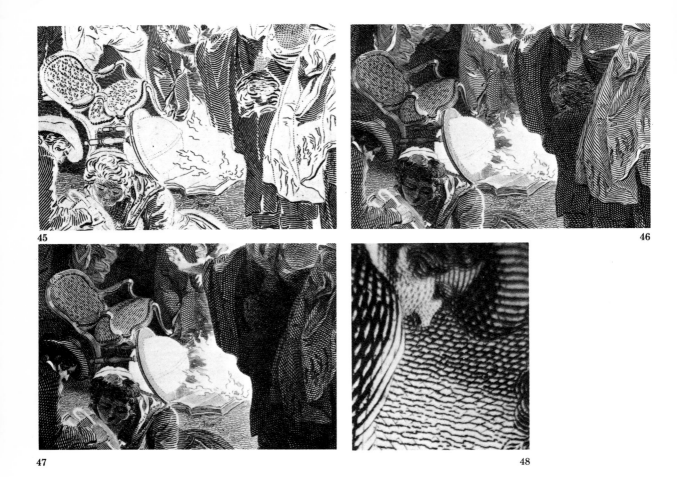

45

46

47

48

45–47 James Heath after Francis
Wheatley *The Riot in Broad Street*,
1790. Detail (actual size). The three
details show: the preparatory 'etched
state'; the next stage with some
engraved lines added; and a later state
with more engraving, although the
plate is still not entirely finished.

48 Macrophotographic enlargement of
a detail of 47 to show the difference in
character between an etched and an
engraved line: the man's shoulder is
engraved, the background is etched.

etchings were made on iron rather than copper plates; the original
iron plate from Burgkmair's *Mercury and Venus* of c. 1520 survives
in the British Museum (see p. 21). This seems to have been simply a
legacy of etching's origins in the armourers' shops, but was
responsible for the coarse line and effect of many plates. Copper
plates only came into general use towards the middle of the
century. The most interesting tradition of etching in Northern
Europe in this period was of landscapes; this was begun by Albrecht
Altdorfer (*c.* 1480–1538) in Regensburg, and continued by his
followers, Augustin Hirschvogel (one of the first etchers to use a
second bite) as well as Hans Lautensack. Besides this there was a
significant use of etching for popular or run-of-the-mill prints,
where its relative speed of manufacture as against engraving gave
it an advantage commercially.

In Italy, Marcantonio made occasional use of etching in his
engravings, but the first to take it up seriously was Francesco
Mazzola, called Parmigianino (1503–40), who has the distinction of
being the first 'painter-etcher', in the sense that he was primarily a
painter. His earliest plate can scarcely date before the mid 1520s.

49 Augustin Hirschvogel *Landscape with a church*, 1545. Etching (reduced).

Parmigianino was a graceful and fluent draughtsman who supervised the reproduction of many of his drawings in the form of engravings by Jacopo Caraglio and chiaroscuro woodcuts by Antonio da Trento. It is not therefore surprising that he was the first to be drawn by etching's ability to capture the freedom and spontaneity of line of drawing. He had a follower in Andrea Schiavone and a successor in Battista Franco, but there is no tradition of original etching in Italy before the end of the century. The only outstanding works in the period are the four etchings made by Federico Barocci in the early 1580s, which show an unprecedented stippled manner of modelling flesh.

Some of the most interesting etchings of the time were made in France by members of the so-called school of Fontainebleau under the inspiration of the Italians Rosso Fiorentino and Francesco Primaticcio. Although little is known about the individual etchers,

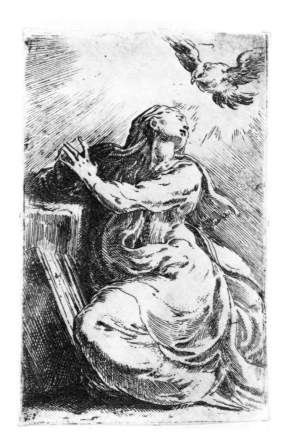

50 Parmigianino *The Annunciation*, *c.* 1527/30. Etching (actual size).

they all seem to have been closely connected with the works going on for François I at the Château of Fontainebleau, and their existence provides invaluable evidence of the self-consciousness of the stylistic innovations being practised there.

The seventeenth century was the golden age of etching. All over Europe painters succumbed to a new fashion for the medium. Many, such as Caravaggio and Guercino, made only one or two prints before deciding that etching was not for them, but others continued to produce a substantial volume of work. Apart from the painters, reproductive engravers made much use of etching to lay in the foundations of their plates; this has already been mentioned in the section on the history of engraving and since it properly belongs there will not again be mentioned here.

The origins of the seventeenth-century revival in Italy go back to the few etchings of Annibale and Lodovico Carracci, who inspired Guido Reni, the most influential etcher of the period. His delicately etched plates, usually of religious subjects and influenced by Parmigianino, set a fashion which was followed by Simone Cantarini and others. A different style of etching was practised in Naples by the Spanish-born artist José de Ribera, whose plates are

drawn with a sensitivity often in surprising contrast to the brutality of the subject-matter. The major etchers in Rome were not native born either. Both Salvator Rosa and Pietro Testa seem to have used their prints largely as a means of self-advertisement. Rosa admitted in a letter that the inscription *Rosa pinxit* under one plate was untrue; he had not in fact painted the picture, but hoped that someone reading the lettering would be encouraged to order it from him. Two other etchers showed much greater interest in printmaking as an art form in its own right. The first was the Genoese Giovanni Benedetto Castiglione (*c.* 1610–65), most of whose plates were made in Rome. One interesting feature of his prints is the awareness that they already show of the works of Rembrandt, with whom Castiglione shared an interest in experimentation. Castiglione is in fact credited with the invention of two new print-making processes, the monotype and the soft-ground etching (see glossary). The second etcher was Claude, born in

51 Van Duetecum after de Vries *An idealized view of the shop of Hieronymus Cock*, 1560. Etching (reduced). Although superficially looking like an engraving, this plate is in fact entirely etched; the contour line of the acid can be seen in the sky.

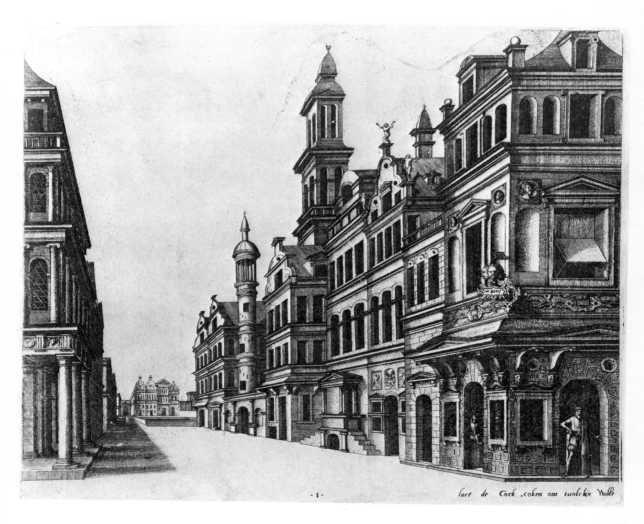

52 Abraham Bosse *The échoppe*, 1645. Etching (reduced).

Lorraine, but so thoroughly Italianized as to show no trace of his origins. All his etchings are of landscapes or marines; in late impressions they are often hard and coarse, but fine early proofs show the unprecedented atmospheric effects that he was striving to obtain.

France also had an important tradition of etching. The first significant figure was the obscure artist Jacques Bellange (active 1600–20), who spent most of his career as the court painter to the Dukes of Lorraine at Nancy. None of his paintings survive but his drawings and astonishing and convoluted mannerist etchings have preserved his name and reputation for posterity. The next great etcher of the French school also came from Nancy, although his style was largely formed in Italy. Jacques Callot (1592/3–1635) is the first important etcher who was not primarily a painter. To ensure that his plates would print enough impressions to secure his livelihood and to simulate the effect of the then much-admired line-engraving, he developed a new sort of etching needle, the *échoppe*, which has a sharp but rounded end. Used on a hard etching ground which forces the acid to bite a much sharper line than it does on a conventional etching ground, this can imitate the swelling line of a burin. In this way Callot could etch his plates deeply enough for them not to wear out too quickly, but yet preserve the gradations of tone by a deft use of stopping out. Callot was in Italy between 1608 and 1621 working in Florence for the Grand Dukes of Tuscany before returning to spend the rest of his life in Nancy.

Stylistically his closest follower was the Florentine Stefano della Bella; it is characteristic of the internationalism of the period that many of della Bella's prints were commissioned by Parisian publishers and that he spent ten years of his life in Paris (1640–50). In France Callot had several imitators, but his most important follower was Abraham Bosse (1602–76), whose closely observed interiors give a vivid view of the France of Louis XIV. Bosse is also famous as the author of the earliest treatise on engraving and etching. This goes so far as to say that the aim of etching is to give the appearance of engraving, but in fact Callot's manner fell gradually out of favour after Bosse's death. Its main practitioners were Israel Silvestre, who made numerous small topographical prints, and, later in the century, Sebastien Le Clerc, the book illustrator.

One seventeenth-century etcher who stands somewhat apart but who is of particular interest to English readers is the Bohemian Wenzel Hollar. Born in Prague, he was trained in Frankfurt in the shop of the Merian family, who had by this time taken up etching rather than engraving for most of their reproductive work. He was brought to England by the Earl of Arundel, and, except for eight years in Antwerp during the Civil War, spent the rest of his life here. He was a reproductive etcher of the widest scope, and his

53 Jacques Callot *A peasant holding a basket*, 1617. Etching (actual size). This plate and **52** were both made using the *échoppe*.

2,700 plates include every subject imaginable from copies of paintings and drawings in his patron's collection to interiors of old St Paul's. But occasionally he etched plates to his own designs, and when faced with a congenial subject such as a muff or an English landscape produced results of remarkable beauty.

It was in the Low Countries that etching saw its greatest triumphs. This was largely due to the genius of Rembrandt, who dominates the history of etching in the same way as Dürer dominates engraving. Although throughout the previous century in the Netherlands there had been a sporadic use of etching by the major masters (for example Pieter Bruegel made one print), the main tradition of Antwerp printmaking was firmly tied to engraving. Most of the numerous prints produced by Rubens' school and followers were engraved, the only outstanding exception being the series of portraits of contemporaries by van Dyck, known as the *Iconography*. Van Dyck seems to have begun by etching these himself with astonishing sensitivity, but, after completing or beginning only eighteen plates, for some reason lost interest and handed the project over to professionals who completed it in engraving.

In the Protestant north, etching had an initial struggle for supremacy with engraving, shown at its best in the splendid twilight scenes of Jan van de Velde, but by his death in 1641 engraving had dropped completely out of fashion in favour of etching. It seems to have suited the Dutch taste, for there were very

54 Karel Dujardin *The two mules*, 1652. Etching (actual size).

few important artists of the century who did not make at least one or two prints. The vogue began with Willem Buytewech and Esaias van de Velde, who stand at the beginning of the Dutch landscape tradition, and was handed on to their successors, such as Allart van Everdingen and Jacob Ruisdael. The Italianizing landscapists also etched, and there are numerous prints by Bartholomeus Breenbergh, Jan Both, Nicolaes Berchem, Carel Dujardin and Herman Swanevelt; even Aelbert Cuyp etched a few cows. Adriaen van Ostade with his followers Cornelis Dusart and Cornelis Bega showed the possibilities of rustic genre, and Reynier Zeeman and Simon de Vliegher those of the seascape.

Rembrandt himself had a remarkable precursor in Hercules Segers (*c.*1589–1635) whose extremely rare etchings, almost all landscapes, were usually printed in a coloured ink on coloured papers and were frequently also hand-coloured after printing. Although Rembrandt never used colour in his prints, he seems to have been inspired by Segers' experimental approach to break through all the established conventions of etching. His etchings – over three hundred in number – show an extraordinary development from the tight and often small genre plates of the 1630s to the grand landscapes and religious subjects of the 1640s with their complete mastery of tonal shading. In the years until his last print in 1659, he increasingly used drypoint which allowed him an even wider range of effects. The experiments with different inkings and papers which have already been mentioned (see pp. 31ff) are another aspect of Rembrandt's delight in making full use of the technical possibilities of printmaking, and it may be said that, quite

55 *right* Rembrandt *The blind fiddler*, 1631. Etching (actual size).

56 *far right* Rembrandt *The goldsmith*, 1655. Etching and drypoint (actual size). This impression is printed on Japanese paper.

apart from their beauty and emotional power, his prints retain, like no others, an ability continually to surprise the viewer. Rembrandt's style of etching has proved enormously influential, not only on his immediate followers, Jan Lievens and Ferdinand Bol, but on all succeeding generations, and in many periods etchers have been content to be his imitators.

In the eighteenth century the most interesting etchings were made in Italy, and, more particularly, in Venice. Antonio Canaletto made a series of beautiful views, published in about 1746, which capture the play of light by use of parallel shading rather than cross-hatching. He was followed by his nephew Bernardo Bellotto, most of whose etchings were made in Dresden. Two splendid series, the *Capricci* and the *Scherzi*, by Giambattista Tiepolo come from the same period, and his son Gian Domenico also made numerous etchings; most were after his own or his father's paintings but there is one famous set of his own design of scenes from the Flight into Egypt. The greatest genius however was Giambattista Piranesi, a Venetian by birth and an architect by self-description, who moved in 1740 to Rome and made his living selling etched views of the city to tourists. His plates are enormous, both in dimension and scale, and his vision of grandeur collapsing into picturesque ruin still conditions people's response to the city of Rome. Equally famous are the set of sixteen *Carceri* (Prisons) and his other architectural fantasies. Even in his plates of archaeological specimens, he managed to combine precision with dramatic presence by using the widest range of biting, from the deepest to the finest lines, ever seen in etching.

In France, the centre of European printmaking, the tradition of artist's etchings continued with a few pretty plates by Jean-Honoré Fragonard, Gabriel de Saint-Aubin and others, but the principal use of etching was made by the great school of book illustrators of the period. A few, like P. P. Choffard, the vignettist, etched their plates personally; more often specialist reproductive etchers worked after designs supplied by such designers as H. F. Gravelot, C. P. Marillier and Charles Eisen. Similar work may be found in such heavily French-influenced countries as England and Germany, where Daniel Chodowiecki deserves to be mentioned. It was in Germany too that the increasing vogue for the Dutch seventeenth century inspired a new interest in original etching. Some, such as C. W. E. Dietrich and F. E. Weirotter were little more than imitators, while others like C. B. Rode and C. W. Kolbe show a quite individual genius. In England the few original etchers, such as Paul Sandby, were much less significant than Gillray and Rowlandson, the great masters of the flourishing tradition of etched satire.

The greatest printmaker of the century, the Spaniard Francisco Goya (1746–1828), was also the most isolated. Spain had no tradition of etching worthy of mention, and Goya at first drew his

57 Giovanni Battista Piranesi *The Arch of Constantine*, 1748. Etching (reduced).

inspiration from the etchings of the Tiepolo family, although he later changed his etching style completely and used the newly-discovered aquatint process to add tone to his designs. He seems to have turned to prints in order to reach a wide public, and produced them in series which savagely attacked the cruelties and stupidities of the society in which he found himself. His first series, the *Caprichos* of 1799, ran into trouble with the Inquisition, and the later *Disasters of War* was never published, but from the time of their recognition by the French his prints have exercised an enormous influence.

The first half of the nineteenth century marks something of a hiatus in the history of etching. Although fine prints continued to be made, the medium suffered severe competition from the newly invented technique of lithography which offered the artist an even easier method of making his own prints. The origin of the so-called 'Etching Revival' which dominated the second half of the century and the early decades of the twentieth century lies in the landscapes of Jacque, Daubigny and others related to the Barbizon school, made in the years from about 1840, and the figure subjects of Jean-François Millet. The other influential figure was Charles Meryon, whose morbid views of Paris were made between 1850 and his collapse into madness in 1866. The increasing interest both among artists and such influential critics as Baudelaire resulted in the foundation of the *Société des Aquafortistes* in 1862, which marked the true beginning of the etching 'revival'. Specialist publishers sprang up, and printers such as the famous Auguste Delâtre perfected all the tricks of artistic inking. The best and most interesting prints were those by Edouard Manet, Camille Pissarro

and Edgar Degas, although they all stood outside the mainstream of the movement, but work of every quality found eager buyers. Even the reproductive engravers' dignity was shaken by a new breed of reproductive etcher, led by Félix Braquemond and Jules Jacquemart, who took advantage of etching's new prestige to steal their market. Despite the success of a few men like Félix Buhot, the quality of etching declined in the final decades of the century, when better work was increasingly to be found in drypoint and lithography.

The fashion was transported from France to Britain by James McNeill Whistler, who fired the enthusiasm of his brother-in-law Seymour Haden. A distinguished tradition of artists' etching had in fact flourished early in the century with remarkable works by John Crome, J. S. Cotman and other members of the East Anglian school, and had been kept alive in the intervening years by the members of the Etching Club. The most famous of these is Samuel Palmer, whose dark and closely-worked illustrations to Virgil's *Eclogues* stem from Blake's wood-engravings. However, Whistler's brilliance together with Haden's eloquence won the day for the French cause, which was secured by the appointment of the Frenchman Alphonse Legros to the position of professor at the Slade school in 1870, and the foundation of the Society of Painter-Etchers with Haden as the president in 1880.

Whistler was the most influential etcher of his time, and for many years was considered by his admirers as second only to Rembrandt himself. His early works which established his reputation, the *French Set* of 1858 and the *Thames Set* made in 1859–61, show his sensitivity to place expressed through line. When he took up etching again in Venice in 1879–80, he developed a quite different and original manner in which the atmosphere of a spot was conveyed as much through films of ink left on the plate in wiping (always done by Whistler himself) as by any etched lines on the plate.

Haden was a much less considerable artist. He was in fact an amateur, a surgeon by profession, but treated etching with a deadly seriousness which communicated itself to the entire movement. Etching became a business for the committed and its high priests, Frank Short, Muirhead Bone, D. Y. Cameron (all three, like Haden, knighted for their achievements) and others, treated a narrow range of subjects with a predictable dourness. An exceptional artist like Walter Sickert (1860–1942) escaped from these limitations through his wide European culture and others, like Graham Sutherland and F. L. Griggs, followed the example of Samuel Palmer by evoking a personal pastoral or medieval utopia, but the general effect of the work of this period is gloomy. None of this hindered a wild financial speculation, fed by such innovations as

58 James McNeill Whistler *En plein soleil*, 1858. Etching (actual size). There is an area of foul-biting in the lower left-hand corner.

signing and numbering impressions, which pushed prices absurdly high before the crash of 1929 made everything unsaleable.

The unprecedented popularity of etching was a phenomenon found everywhere in the early decades of this century, although outside Britain the specialist printmaker never dominated the painter-etcher to the same extent. The best work was made in France, and Pablo Picasso is undoubtedly the greatest etcher of this century. His first etchings belong to his blue and pink periods, and a few more were made with Braque in the Cubist years of 1910–12. His greatest prints however come from the 1920s and 1930s, and show his delight in taking full advantage of the possibilities of the different techniques of printmaking as well as his amazing mastery of line and command of expressive distortion. Matisse, too, made some very simple and beautiful etchings, but of many other well-known painters persuaded by their dealers to make a few etchings it can be said that few had any real feeling for the medium.

Many fine works were made in Germany and the Netherlands (where James Ensor had begun to make his fantastic etchings in 1896), but some of the most interesting prints are to be found in America. Beginning in the shadow of Whistler, the first American etchers to create something new were the landscapists of the first

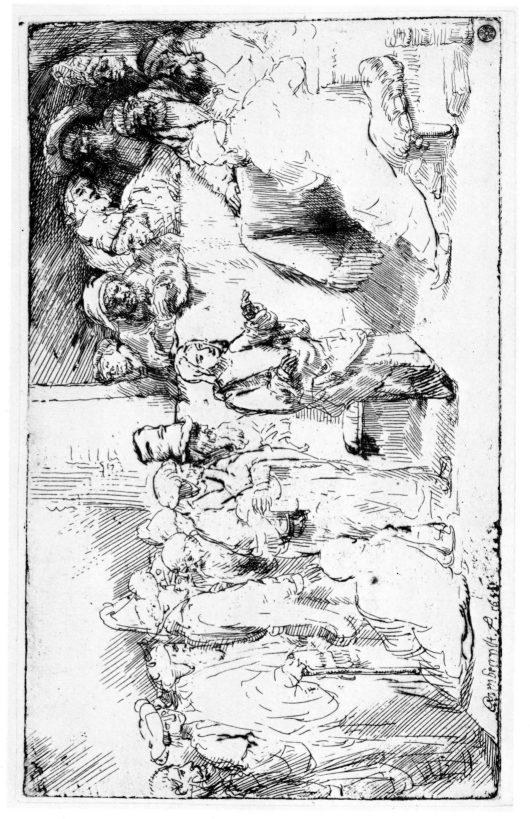

59 Rembrandt *Christ disputing with the doctors*, 1652. Etching and drypoint (actual size).

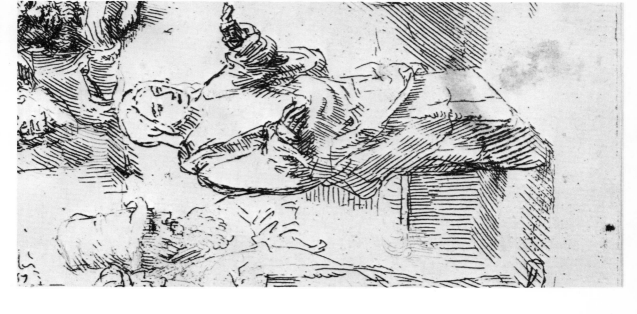

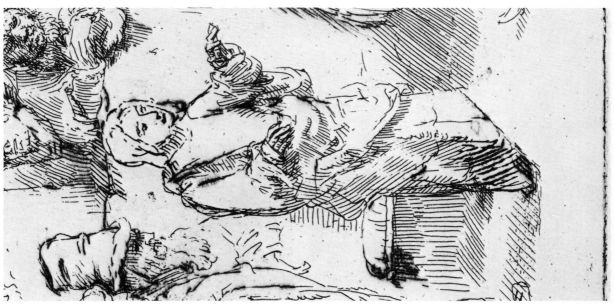

60 *right* Detail of **59** (enlarged). The contrast between the etched lines and the drypoint with the smudgy burr is very clear.

61 *far right* Detail of a late impression of **59** (enlarged). The burr has worn away, revealing how shallow the drypoint lines are; by contrast, the etched lines show little or no wear.

two decades of the century like Childe Hassam, and the illustrators of urban life of the Ash-Can school such as John Sloan and Reginald Marsh. Between the two Wars a new interest in the American scene led to the tense masterpieces of Edward Hopper, which can hold their own with the best European work of the time.

The years since the Second World War have seen the super-cession of the small black and white etching, which has dominated so much of European printmaking, by the large, highly-coloured print intended to be hung on the wall. The best-known prints in the 1950s were the coloured intaglio works (often using a combination of many intaglio techniques) produced by the leading members of the school of Paris like Pierre Soulages and Hans Hartung. In the 1960s in Britain and America, etching suffered with the popularity of screenprinting and lithography, but was kept in public view by David Hockney and Jim Dine, and in the 1970s, became the favoured graphic medium of the artists of the Minimalist school.

Drypoint

Technique Drypoint is the simplest of the intaglio processes to describe. The line is scratched directly into the copper plate with a sharp metal point (the drypoint needle). As the needle scores the copper, it throws up on both sides of the line a ridge of metal known as the burr. This burr is responsible for the most characteristic effect of a drypoint print; the curled copper holds a quantity of ink which prints as a rich smudge.

In technique drypoint stands closest to engraving. Both work directly into the metal, but the difference is that in engraving the metal is actually dug out of the lines and any burr on the surface of the plate is scraped off before printing, whereas in drypoint it is simply thrown to the side and left on the plate. This difference in technique produces a different effect. The burin has to be pushed through copper and makes an engraved line which is anything but spontaneous and free. A drypoint needle can be handled in the same sort of way as an etching needle and its line can appear similar to some types of etched line. It is for this reason that drypoint is usually considered as a variety of etching, and is often used by artists to retouch areas of an etched plate.

Although drypoint sounds simple, it has many drawbacks. The needle is almost as difficult to control as a burin, while commercially there is the grave disadvantage that the line, being only a shallow scratch, quickly wears down. The drypoint's chief beauty, the rich burr, also wears quickly, and will often only last for twenty or thirty impressions. In the nineteenth century artists often got round this by steel-facing their plates. Opponents of this practice claimed that it made the burr print very much more weakly, and, although this charge was hotly disputed, there is no doubt that in

62 Macrophotographic enlargement of the tree trunk at the left of **64**. The line scored by the drypoint needle is visible as a thin white scratch in the centre; the rest is burr.

some cases at least (for example the early prints of Picasso) it is perfectly true.

If the burr has worn down or been scraped away by the artist, a drypoint can be very difficult to distinguish from an etching. Sometimes the character of the line will give the answer; for example, a rounded end will betray etched lines, a very closely worked area of shading drypoint. But often there is no method of finally settling the question.

Historical It is unusual to find prints which are entirely worked in drypoint. More commonly etchers used drypoint to retouch areas of their etched plates which needed more work but not enough to make it worth laying a new etching ground. Engravers, too, often began by scratching outlines of their design onto the plate in drypoint. These types of use do not strictly belong to a history of drypoint, and this section will only mention the few artists who have made plates entirely in drypoint.

The earliest is the remarkable Master of the Housebook, named after a book of drawings at Wolfegg, who worked around 1480 in the region of the middle Rhine. His very rare prints, which are mostly preserved in Amsterdam (he is also sometimes known as the Master of the Amsterdam Cabinet), are all drypoints, and are exceptional in fifteenth-century art in their freedom and appearance of being sketched from the life. The only other early master to make drypoints was Albrecht Dürer. The three he made, all in 1512, are the first to show the rich velvety tone which can be got from the burr. Despite this striking success, he abandoned the medium and the reason must be that he discovered how quickly the burr and the lines wore out, a fact which, to a man of Dürer's business-like approach, made drypoint a waste of time.

Drypoint was occasionally used in sixteenth-century Italy, mainly to supplement etching, but was only seriously taken up in the seventeenth century by Rembrandt, a man whose mind was anything but business-like, but who delighted in obtaining striking effects in prints. Beginning as an etcher, he used drypoint increasingly from the later 1630s on his etched plates. In the 1650s drypoint came to dominate and five plates (two landscapes, a portrait and the enormous *Three Crosses* and *Christ shown to the People*) were executed entirely in it. The last two are arguably the greatest prints ever made, but can also be seen as extraordinary technical *tours de force*. They show complete control of a medium which no-one had ever dreamed of using on such a scale, and demonstrate how the artist can dig the needle in more deeply to throw up more burr or scrape it down where he wishes to lower the tone. Rembrandt also found several unusual printing surfaces, especially Japanese paper and vellum, ideal for bringing out the burr, and used them whenever possible.

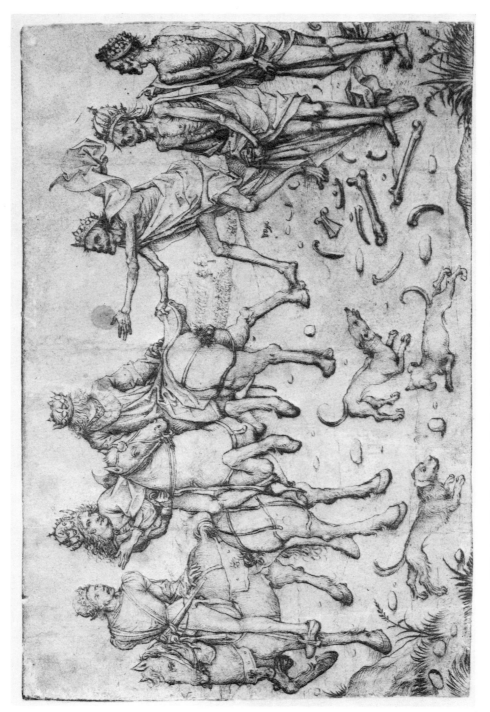

63 Master of the Housebook *The three living and the three dead*, c. 1490. Drypoint (actual size).

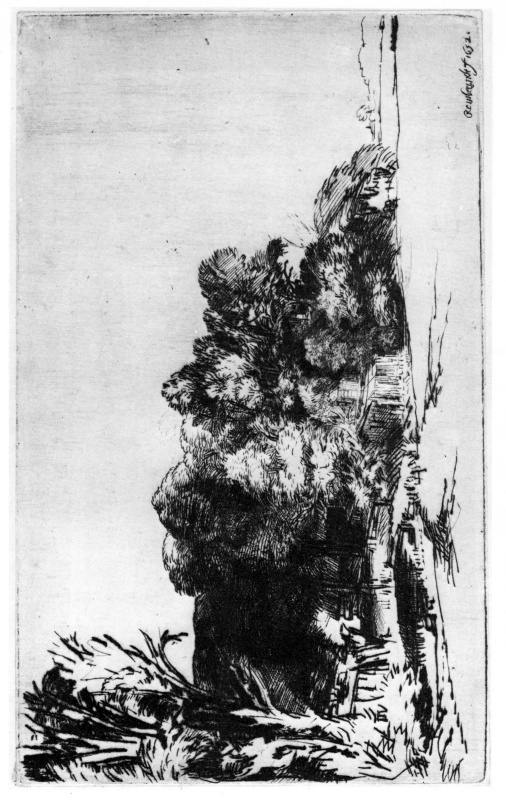

64 Rembrandt *Clump of trees with a vista*, 1652. Drypoint (actual size). An outstanding example of the beauty of pure drypoint.

In the seventeenth century most drypoints were made by his immediate followers and pupils such as Lievens and Bol, and, in the eighteenth century, by his imitators such as Arthur Pond in England and Norblin de la Gourdaine in France. But it is unusual to find drypoints anywhere in this period and the medium only became widely popular in the middle of the nineteenth century. It was taken up in the first place by Seymour Haden who used it in many landscapes in the manner of Rembrandt (of whose works he himself owned a fine collection), and many other British etchers followed him in this, often succumbing to the temptation to smother the design in a mass of richly printed burr.

In Europe drypoint never became so exclusively tied to landscape. The leading master in France was Paul Helleu, whose portrait drypoints of the 1890s are, at their best, sensuous and, at their worst, flashy. Chahine and the Italian Boldini also made portraits in his manner, but a finer artist was Mary Cassatt, the American domiciled in France. She made many drypoints of her habitual theme of mother and child, and this mood of intimacy is also found in the drypoints of Picasso's blue and pink periods.

The German tradition was the most original, and blossomed in the first decades of this century. The two leading German 'impressionists', Lovis Corinth and Max Liebermann, made many good portraits and even better landscapes in drypoint. From another starting point the Expressionists used the jagged directness of the drypoint line to convey the immediacy of their responses. These two German traditions meet in Max Beckmann, whose drypoints of the First World War convey the horror in lines of extreme sensitivity.

Crayon-manner and stipple: the dot processes

The intaglio printmaking processes so far described can only produce lines of varying thickness; they cannot easily manage areas with considerable tonal gradations. In the case of etching and drypoint it is possible only by shading and cross-hatching. Engravers could extend their range by building up systems of lines of varying width, alternating with thin lines or cross-hatching, which enabled them to give the effect of the most varied textures. But an easier way of conveying tone is by building up areas of dots of varying density. This has found favour at certain periods, and various methods have been practised, all of which are now long defunct. It seems best therefore in this section to combine the technical and historical narratives.

The earliest method was invented by the Venetian Giulio Campagnola (c. 1482– after 1515). Using flicks of the burin he built up images modelled in dots over a line foundation; in one case, the *Venus reclining in a Landscape*, he dispensed altogether with the

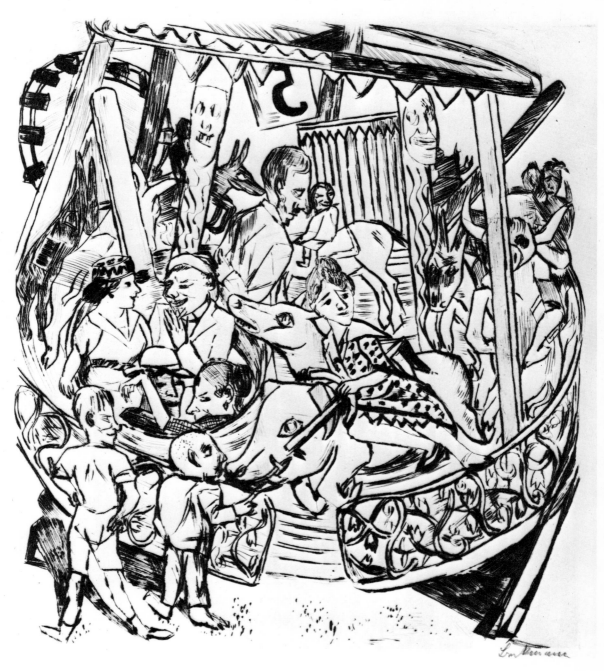

65 Max Beckmann *Das Karussell* (The Roundabout), 1921. Drypoint (reduced).

66 Giulio Campagnola *Child with three cats*, *c*. 1510. Stipple over an engraved outline (actual size).

67 *opposite* Jacques Bellange *The Madonna with the rose*, *c*. 1617. Etching (actual size). The flesh has been stippled with flicks of the burin.

engraved foundation. This technique perfectly echoes the broken outline and soft atmospheric modelling of the painting of Giorgione and his school, and, although Campagnola had a few followers, it scarcely outlived the first decades of the sixteenth century.

A limited use of stippling with the graver to model flesh areas was introduced by Dürer, and lasted into the eighteenth century, especially among the French portrait engravers. Nanteuil always used flicks of the graver for the lightest areas of the face, only breaking into line in the shadows. In Italy a similar technique was used by the portrait engraver Ottavio Leoni (1575–1630). Another portrait specialist, Jean Morin (*c*. 1590–1650), used the same principle, but, by flicking his dots on to an etching ground rather than directly into the plate, achieved effects of a much greater *sfumato*. He had been anticipated in this by Federico Barocci and Jacques Bellange (see above p. 64). In Holland, Jan Lutma, a goldsmith by profession, made a few curious portraits around 1680 by punching dots with a smith's punch directly into a plate.

The earliest recorded use of the *roulette*, a tool consisting of a spiked wheel, was by Ludwig van Siegen in 1642, but since this is intimately connected with the history of mezzotint it is described in the section on mezzotint. It was however the same tool, or adaptations of it with different arrangements of spikes, together with the *mattoir*, a tool with a rounded spiked head, which were used in the classic dot processes of the eighteenth century.

llange.fecit.

The remarkable development of tonal processes in eighteenth-century France was stimulated by the demand for printed facsimiles of drawings. Since the drawings reproduced were mostly *sanguines* (red or brown chalk drawings on rough-textured paper) it was necessary to devise a method of imitating their crumbly and irregular grain. The inventor of the so-called *crayon-manner* in 1757 was an engraver, J. C. François (1717–69), who developed new types of roulettes and mattoirs which he used not directly on to the plate, but on to an etching ground, in order to soften the effect. By printing on a suitable paper in a red or brown ink he produced extraordinarily accurate facsimiles of drawings, which can still occasionally deceive the unwary. He was followed by an even more skilful craftsman, Gilles Demarteau, while a third, Louis-Marin Bonnet, devised a new development, colour printing from multiple crayon-manner plates, which he christened the pastel-manner (described in the chapter on colour printing). Crayon-manner, being so closely dependent on the vogue for sanguine drawings, could not outlive that particular fashion, and died with the eighteenth century.

The *stipple* process was developed in England by William Wynne Ryland (1733–83) out of the French crayon-manner, of which it is

68 Gilles Demarteau after François Boucher *Mother with two children,* *c.* 1760. Crayon-manner (actual size).

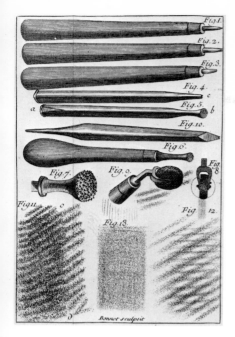

69 Louis-Marin Bonnet *Tools for crayon-manner*, 1769. Etching and crayon-manner (reduced). Figures 6 and 7 are mattoirs; 8 and 9 are two views of a roulette.

really only a simplified version. The engraver uses a point to build up a mass of dots on an etching ground, but makes no attempt to reproduce the effect of a drawing. Ryland had learnt the crayon-manner in Paris in the late 1750s, but only found success in England after 1774 when he developed stipple to reproduce the paintings of Angelica Kauffman. The popularity of these prints inspired many emulators, the most famous of whom was Francesco Bartolozzi, who made many stipples in England after the paintings and drawings of his fellow Italian G. B. Cipriani. Stipple was mostly used for so-called 'furniture' prints, designed to be framed and hung as elements in schemes of interior decoration, partly because it could easily be printed in colours. Moreover its softness lent itself admirably to '*galant*' or romantic subjects. It was later taken up in France, but did not last long into the nineteenth century. When, in the 1880s, eighteenth-century colour stipples became very fashionable among collectors, the technique was revived by a host of imitators in prints of vaguely eighteenth-century subject matter and appearance, but this revival did not outlast the collapse of the collecting market in 1929.

NOTE: Fifteenth-century metalcuts were often decorated with punched dots in the style known as '*manière criblée*'. Since these were printed in relief rather than in intaglio and the dots were used in a decorative rather than a tonal way, they are described in the section on metalcut.

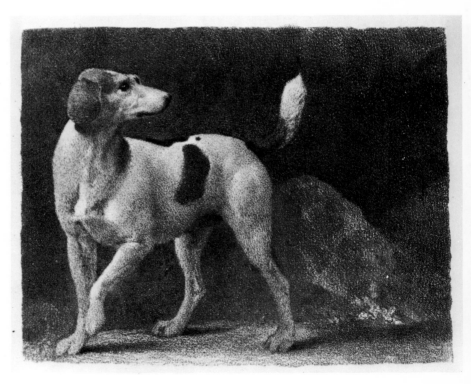

70 George Stubbs *A foxhound*, 1788. Stipple (actual size). Although mainly stipple, the background of this plate has been worked over with a mezzotint rocker and roulettes.

Mezzotint

Technique Mezzotint is a distinctive printmaking process, being the only one in which the artist works from dark to light rather than from light to dark. The process itself is simple. The copper plate is first 'grounded' – that is, it is systematically worked over with a spiked tool (a *rocker*) until it is thoroughly roughened. If inked in this state, it will print a rich black. The engraver then smoothes out ('scrapes') graduated highlights with a scraper or a burnisher. The more burnished the area is, the less ink it will hold and thus, when the plate is printed, the design will emerge from the basic blackness.

The work of grounding the plate is laborious but not difficult. The rocker has a rounded blade with cutting teeth of various finenesses, depending on the quality of grain required. The blade is held at right angles to the plate and the cutting edge rocked regularly up and down its surface; the direction is usually regulated by running the rocking tool along a fixed pole. To lay a uniform ground this process has to be repeated at different angles across the plate (often as many as forty).

The scraping of the grounded plate is a tricky job, but, although usually left to professional mezzotinters, is not so difficult that it has not occasionally been attempted by non-professionals. The inking and printing of the plate is however exceptionally complicated (see p. 31).

The process of grounding a mezzotint plate raises a burr in the same way as drypoint. This burr is responsible for the superb depth of tone which can be seen on early impressions of mezzotints, but, again as in drypoint, this quickly wears out. Since nothing is flatter than a worn mezzotint, professionals regularly 'refreshed' plates by regrounding worn areas.

The possibility of refreshing plates must have suggested the other use to which the mezzotint rocker can be put – that is to lay a partial ground on certain areas only of a plate. This was usually done over a plate which already carried a design etched in outline; the mezzotint ground could then be added in varying strengths to create shadows. This use of mezzotint for adding tone is very similar to the way in which aquatint was normally employed.

Historical The first step towards the mezzotint technique was taken by a German soldier, Ludwig von Siegen, who announced his discovery in a letter in 1642. Examination of his prints shows that he used a fine roulette to build up a design on the plate. He was therefore working from light to dark, rather than scraping down from dark to light.

The development of true mezzotint required the invention of the rocking tool, which made it possible to ground the entire plate and

72 Diagram of a mezzotint rocker, showing how it is worked over the plate.

71 *left* John Jones after George Romney *Serena*, 1790. Stipple. Enlarged detail of another impression of col. pl. 7, printed in sepia (*not* printed in colours).

73

74

73–75 John Jones after Sir Joshua Reynolds *Miss Frances Kemble*, 1784. Mezzotint (greatly reduced). Three progress proofs of the same plate, showing an impression from the completely rocked ('grounded') plate before any working, the first state after the initial scraping, and the penultimate state before the lettering was added in the margin.

75

then scrape out the highlights, working from dark to light. This is credited to Prince Rupert in the late 1650s, when he had retired to Frankfurt after the Royalist defeat in the English Civil War. Most of his plates have an obviously experimental character, but the largest of them, *The Great Executioner*, after a painting of the school of Ribera, is superb and still remains one of the greatest mezzotints. Prince Rupert seems to have been chary of publishing details of his invention, but gave instruction to enough professional printmakers to ensure that the technique was rapidly publicized.

The first of these professional pupils was Wallerant Vaillant. He settled in Amsterdam in 1662, and mezzotint was soon popular in Holland. Perhaps the most interesting of the Dutch mezzotinters was Cornelis Dusart, van Ostade's pupil, whom we have already met as an etcher. He and some others made original designs in mezzotint, but most used it for reproducing paintings. William Sherwin, who made the earliest dated English mezzotint in 1669, was also instructed by Prince Rupert, and in the last three decades of the century numerous mezzotints were published in London, the best being by Isaac Beckett. The growth of the British tradition was boosted by the arrival of many of the leading Dutch mezzotinters, such as Abraham Blooteling who worked in London between 1672 and 1676, mostly copying Lely's paintings. By the early eighteenth century mezzotint had lost much of its popularity on the Continent, but was so fashionable in Britain that it became known abroad as '*la manière anglaise*'.

The main reason for this success was the suitability of mezzotint for reproducing portraits; in France this market was firmly in the hands of engravers but there was no such tradition in England. Portrait painters strove to attach the best mezzotinters to their service not so much to make money out of their prints as for the sake of publicity. John Smith, the best mezzotinter of the period, actually lived in Sir Godfrey Kneller's house for a time, and when the two quarrelled, Kneller hastened to Smith's leading rival, John Simon. The best-known mezzotinter of the 1730s and 1740s, John Faber the younger, was a much weaker artist, but the standards rapidly improved in the 1750s when a large number of mezzotinters arrived from Ireland. This so-called 'Dublin-group', of which James McArdell was perhaps the outstanding member, dominated the profession until the mid 1770s. They were greatly helped by the growth of the British school of portrait painting, and many of them worked for Sir Joshua Reynolds. Over four hundred prints after his paintings are known, and it is probable that he supervised their manufacture. From the 1770s the leading portrait mezzotinters were Valentine Green, Thomas Watson and John Raphael Smith, but the medium had by then become so popular as to be used for other purposes. Many of Joseph Wright of Derby's paintings of

candle- or moonlit interiors were mezzotinted by William Pether and Richard Earlom. Earlom also specialized in reproducing Old Master paintings, and published facsimiles of the drawings in Claude's *Liber Veritatis* in 1777. At the end of the century William and James Ward made many prints after the paintings of their brother-in-law George Morland, and there was a flourishing tradition of mezzotints of horses, bulls and other animal subjects particularly popular in England. Meanwhile the tradition of portrait mezzotints continued into the nineteenth century with Charles Turner, S. W. Reynolds, Samuel Cousins and the others who worked for Sir Thomas Lawrence and his successors.

Two series of mezzotints produced in the nineteenth century deserve special mention. The first is the *Liber Studiorum*, published by J. M. W. Turner between 1807 and 1819. This was produced in direct emulation of Claude's *Liber Veritatis* and was intended to display Turner's command of all types of landscape composition. The technique was based on Earlom's in his publication of Claude in 1777; Turner himself made sepia drawings and etched the subjects in outline, and then turned the plates over for partial mezzotinting (as described in the last paragraph on technique) to professionals. Much more beautiful though are the few unpublished plates of pure mezzotint (the so-called 'Little Liber') which Turner made himself. The second series, containing true mezzotints, is by David Lucas after John Constable. Constable published the twenty-two plates with a text under the title *Various Subjects of Landscape* in 1833 as a document of his artistic aims, and goaded Lucas into producing his best work and indeed some of the finest English mezzotints.

The use of steel plates, with their much less rich burr, is responsible for the anaemic appearance of many mezzotints made after about 1820. In the nineteenth century mezzotint was often combined with other processes. Although in earlier mezzotints grounds had occasionally been laid over etched or stipple foundations, engravers now took delight in attacking the plate with every known intaglio technique. Such method is usually simply called 'mixed'. It did not survive the invention of photomechanical processes. In the early years of this century mezzotint enjoyed a certain popularity, and has occasionally been practised in more recent years.

On the Continent the only centres where mezzotinting was practised at all commonly in the eighteenth century were Augsburg (by the Haid family), Nuremberg and Vienna, where the founder of the school, Johann Jacobe, had been trained in England between 1777 and 1780. Mezzotints were also occasionally made in France, the best probably being those by Philibert Debucourt in the 1790s.

76 Wallerant Vaillant *A young man reading*, 1670s. Mezzotint (reduced).

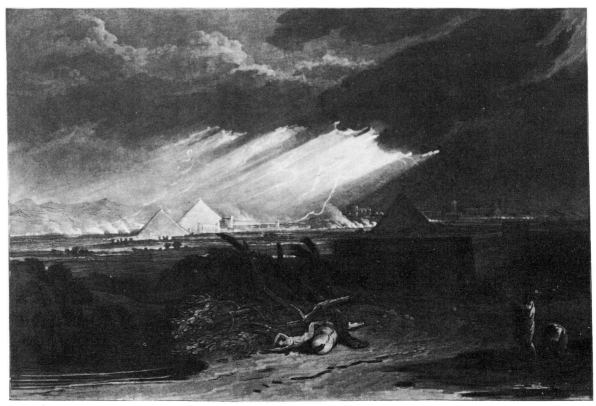

Aquatint

Technique Aquatint is historically the most important of the intaglio tonal processes after mezzotint. It can produce an effect similar to a watercolour wash. The key to it is a special variety of etching ground (the aquatint ground) which consists of minute particles of resin which are fused to the plate and act as a resist to the acid. Since this ground is porous, the acid bites into the plate in tiny pools around each particle. These tiny depressions retain the ink when the plate is wiped, and when printed give the effect of a soft grain. The particles can be of varying fineness; if large the individual pools of ink will be visible to the eye, but if very small they will produce a film of tone which looks very similar to a watercolour wash. The aquatinter can vary his effects by biting to different depths, either by using a stopping-out varnish or by laying grounds which vary in thickness or use grains of different degrees of fineness. The resin is cleaned off the plate before printing.

Aquatint only produces areas of one tone. It cannot produce a

77 *left, above* J. M. W. Turner *The fifth plague of Egypt*, 1808. Etching (reduced).

78 *left, below* The later state of **77** after a mezzotint ground had been laid over Turner's outline etching by Charles Turner.

79 *above* David Lucas after John Constable *Summer afternoon – after a shower*, 1831. Mezzotint (reduced).

80

81

82

gradation for modelling form unless the artist burnishes areas down (in the manner of a mezzotint), but this has in fact rarely been done. Nor can it produce a line. For these reasons it has normally been used in conjunction with etching. A plate is given an etched outline in the usual way, and then an aquatint ground is laid on top and bitten to the required levels, after stopping out those areas which are to stay white. In the late eighteenth century the laying of the aquatint ground was often entrusted by the etcher to a specialist aquatinter.

Two methods are most commonly used to lay the resin ground on the plate. The first is the dust-box in which the ground is blown into a cloud and allowed to settle in an even film on the plate. The particles are fused to the copper by heating the back of the plate. The second method uses alcohol to dissolve the resin; the solution is spread evenly over the surface of the plate, and, as the alcohol evaporates, the resin is left as a grain on the surface. The artist can of course use other techniques; one method is to press sandpaper into an ordinary etching ground, or even directly into the plate.

The main difficulty in making an aquatint is that the design on the plate has to be negative, since the artist paints with his stopping-out varnish those areas which will remain white. To reverse this, and to ensure that the brushed areas will be bitten, recourse has to be made to the *sugar-lift* or *lift-ground* aquatint. The artist brushes his design on to the plate with a fluid in which sugar has been dissolved. The entire plate is then covered with a stopping-out varnish and immersed in water; as the sugar swells it lifts the varnish off the plate, leaving the original brush drawing exposed as bare copper. These areas are then covered with an aquatint ground and bitten in the usual way, while the stopping-out varnish protects the rest of the plate. As an alternative, the aquatint ground can be laid on the plate at the very beginning, before brushing on the drawing. When this process is used (as it was by Hercules Segers and again in the nineteenth century) over a drawn rather than a brushed line, it is sometimes known by the French term, as etching *à la plume*.

Two other tonal processes, distinct from but related to aquatint, should also be mentioned in this place. A *sulphur print* is produced by dusting powdered sulphur onto the surface of a plate which has been spread with a layer of oil. The particles of sulphur corrode the plate in a uniform tone, which can be burnished to give gradations. Sulphur prints can be distinguished from true aquatints by the absence of the rings or pools of ink which form around the resin particles. A plate can also be brushed directly with neat acid; the term *lavis* (see glossary) has sometimes been used for this process. It is useful for giving a tone to small areas and for creating tonal variations within an aquatint ground, but cannot easily be controlled over large areas. Its characteristic sign is a 'high-tide'

80–82 Paul Sandby *Inside Chepstow Castle*, 1777. Aquatint over an etched outline (greatly reduced). **81** and **82** are magnified details; the first shows the characteristic aquatint grain, the second shows how the design was built up with three different applications of sugar-lift aquatint.

83 Abraham Genoels *A circular landscape, c.* 1690. Lavis (acid wash) over an etched outline (actual size).

mark at the edges of the washed areas. It was much used by Goya, and has recently been developed by Jasper Johns; in America it is often referred to as 'open-bite' etching.

Historical The inventor of the true aquatint process using a resin ground was the Frenchman Jean Baptiste Le Prince (1734–81) and it is clear that the whole later development of aquatint stems from the techniques he devised by 1768. However, for centuries before this date printmakers had been striving to get tonal effects on etched plates by using a variety of idiosyncratic aquatint-like processes. The chronicle of these experiments has not yet been written, largely because they were so isolated and inconsequential. But a brief list must include Marcantonio, who used some sort of file to add tone to his *Judgement of Paris*, Daniel Hopfer, whom Bartsch thought had discovered the true aquatint process, and Rembrandt, who used corrosive sulphur. The most remarkable curiosities are two quite isolated portrait prints made in the 1650s by a certain Jan van de Velde; it is impossible to deny that these are true aquatints made with a resin ground, but they had no following whatsoever.

Le Prince's own discovery was preceded by various experiments

84 Francisco Goya *Que Pico de Oro*, 1799. Etching and aquatint (actual size). The aquatint was bitten to three depths and then modified by extensive burnishing.

in tonal effects by P. G. Floding, a Swede working in Paris, J. B. Delafosse, who was closely linked with the Abbé de Saint-Non, and the Dutchman Ploos van Amstel. Whether any of these are true aquatints is still unclear for the subject has not been properly investigated. At least some of those by Ploos van Amstel are directly worked on the plate with a variety of tools to produce an aquatint effect; other prints of the period are really sulphur prints – as, for example, the series of facsimiles of drawings published in Florence from 1766 by Andrea Scacciati and Stefano Mulinari.

Le Prince and his contemporaries used the process to imitate their own wash drawings, but the limited popularity of such drawings in France restricted the demand for aquatints. The process could, however, be adapted for colour printing in imitation of gouache; these are the finest French aquatints and are here described in the section on colour printing (p. 120).

In Italy the earliest aquatinter, Giovanni David of Genoa, is significant only as the possible inspirer of Francisco Goya (see p. 68), the greatest master of the process. Goya usually laid his aquatint over an etched foundation, often combining it with the use of acid washes and the burnishing tool. One plate, *The Colossus*, is so unusual, being entirely burnished aquatint, that until recently it was always described as a mezzotint. Goya shows his greatest mastery of the medium in the few plates in which he dispensed altogether with the etched foundation and built up the design entirely in layers of tone.

The strongest tradition of aquatinting is to be found in Britain. The earliest datable English aquatints were made by P. P. Burdett in 1771, but the artist responsible for spreading knowledge of the process widely was Paul Sandby. Sandby seems to have hit upon the idea of using alcohol to lay the ground; he also made much use of the lift-ground technique to capture the effects of brush strokes. His early aquatints and those of Gainsborough are bold and even rough in effect, but, in general, aquatint in England came to be used to build up even gradations of tone to give the appearance of a watercolour wash laid over an outline drawing. This technique was ideal at a period when most watercolours were executed simply in transparent washes over a pen outline, particularly since the aquatints could easily be hand-coloured after printing to complete the effect. It was, therefore, above all used for illustrating the great series of colour-plate books which enjoyed a remarkable vogue in Britain between about 1790 and 1830. Most of these books were topographical, but others treated subjects as diverse as fox-hunting and Chinese tortures.

In the last decades of the nineteenth century aquatint was used more frequently in artists' prints, the finest examples being by Degas, Pissarro and Mary Cassatt. In the present century it has become popular as etchers have become less willing to confine their

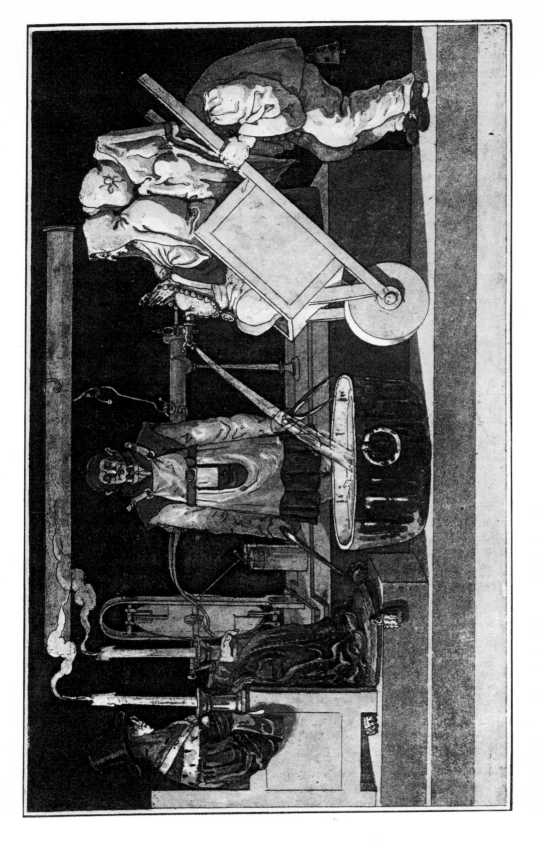

85 Louis-Jean Desprez *Operation for hydropsy, c.* 1790/4. Aquatint over an etched outline (reduced).

DINAS-MOUTHEY. N.WALES

DINAS-MOUTHEY. N.WALES

work solely to line, and has often been used in unconventional ways to produce new effects. In many prints the tonal techniques employed are so complicated and idiosyncratic that the distinction between aquatint and the other traditional tonal processes breaks down, and it becomes impossible precisely to define the technique.

Soft-ground Etching

Technique This technique produces a facsimile of a chalk or pencil drawing. The plate has a special soft etching ground laid on it; this differs from a normal ground in that it has tallow added to prevent it hardening. A piece of soft paper is then fixed on top of it, on which the artist makes his drawing. Where the pencil presses into the ground, it adheres to the paper, which is carefully pulled away together with the attached ground leaving the design exposed on the copper. The plate is then bitten in the usual way, and an almost perfect facsimile of the original drawing is transferred to the copper. The ground has to be cleaned off the plate before printing. Soft-ground etchings can be readily distinguished from crayon-manner prints and lithographs by the presence of a plate-mark. But if this has been cut away, a crayon-manner print can be distinguished by the regular repetition of the pattern caused by the use of a tool. A lithograph will have a smooth surface, whereas a soft-ground etching, being printed from an intaglio plate, is rough to the touch.

Historical The earliest soft-ground etching is by Giovanni Battista Castiglione, and is only known in a unique impression at Windsor. This can be dated in the 1640s and so far as is known had no successor for a hundred years. The process was re-invented in the middle of the eighteenth century, most probably by J. C. François, as a development of the experiments which had led to his invention of the crayon-manner. Some of the earliest examples are by Thomas Gainsborough in the 1770s. The technique was popular at the end of the eighteenth century in England, where the absence of any tradition of crayon-manner meant that it was widely used for making facsimiles of drawings. Among the artists who handled it were Gainsborough, Rowlandson, John Sell Cotman and Sawrey Gilpin. In the early nineteenth century it was also much used in the 'drawing books' by watercolour instructors such as David Cox and Samuel Prout; but by 1830 it was displaced by lithography, which could produce a similar effect very much more cheaply.

In the twentieth century there has been a revival of interest in the technique, once it was realized that material of any texture could be pressed into the ground and the pattern transferred to the copper plate. It is the widespread use of textiles and suchlike for this purpose that makes many modern etchings appear so different from their predecessors.

86 *left, above* David Cox *Dinas Mouthey, North Wales*, 1814. Drawing in pencil (reduced).

87 *left, below* David Cox *Dinas Mouthey*, 1814. Soft-ground etching (reduced). **86** was originally drawn on the paper over the soft etching ground and was thus transferred to the plate.

88 John Sell Cotman *Planthony Abbey*, 1820s. Soft-ground
etching (actual size).

Lithography

Technique Lithography is based on the chemical fact that grease and water repel each other. If marks are drawn on a suitable printing surface in some greasy medium, the surface can be printed from in the following way: the surface is dampened with water, which settles only on the unmarked areas since it is repelled by the greasy drawing medium. Secondly, the surface is rolled over with greasy printing ink, which will adhere only to the drawn marks, the water repelling it from the rest of the surface. Finally the ink is transferred to a sheet of paper by running paper and the printing surface together through a scraper press (see below). The lithographic process is often described as *surface* or *planographic* in order to distinguish it from the relief and intaglio processes.

Such in essence is the principle of lithography. The actual operations are of course much more complicated. The printing surface used was originally stone (whence the term 'lithography' which means 'stone drawing'); this had to be capable of absorbing grease and water equally, and the only really suitable type was the limestone quarried in the Solenhofen region of Bavaria. Later zinc (from about 1830) and aluminium (from about 1890) were employed as substitutes; there is usually no way of telling from inspection of any individual lithograph which surface was used. The disadvantage of stone was its bulk and weight and is now its unobtainability, but artists have usually preferred to use it when possible because it allows a richer range of tones.

The stone (and all that follows holds true for zinc and aluminium) can be drawn on in any way as long as the drawing medium is greasy; this explains the bewildering variety of appearances that lithographs can present. The most usual medium is chalk, for which crayons of various finenesses are available. The other methods are pen and wash. The latter can be particularly difficult to print as the wash can hold only a small proportion of grease and can thus fail to hold the printing ink; it was only successfully mastered in 1840 by Hullmandel who patented his method under the name of *lithotint*. If chalk is used the printing surface must be given a grain by grinding with an abrasive, but for pen or wash the surface has to be smooth or have only a fine grain. Other drawing techniques have been used. Toulouse-Lautrec, for example, often created a tone with 'spatter-work', by flicking lithographic wash at the stone with a tooth brush; highlights were reserved with masking paper. Other artists – for example, Manet and Menzel – scratched deeply into the stone to create highlights.

Once the drawing is finished the artist's task is done; the rest is the province of the printer, whose operations are complicated enough to make it unusual for the artist to do his own printing; he may supervise, but he needs the expert's aid. This fact distinguishes lithography from etching, its nearest rival as an autographic printing technique, and fundamentally affects the whole history of

89 Jean François Millet *The Sower*, 1851. Chalk lithograph (greatly reduced).

the medium; it is perhaps as appropriate to write a history of lithography in terms of the major lithographic printing establishments as in terms of the artists. One difficulty is that the stone or plate has to be prepared before printing, and the exact process of preparation varies according to its surface, and also the technique of the drawing. Briefly, the surface must be washed with dilute nitric acid to fix the image on the stone, and rubbed with gum arabic ('desensitized') to prevent any further grease settling on the stone. Only then can the surface be washed and inked for printing as described in the first paragraph. The 'gum etch' has to be done only once before printing, but the application of water and then ink must be repeated between each impression.

The printing press is traditionally a flat-bed scraper press. The paper is laid face down on the inked stone, and rubbed along the back to transfer the ink. A modern development is offset lithography. In this the image is picked up from the stone, or more usually plate, by a rubber roller which then reprints it onto paper. One advantage of this double printing procedure is that it re-reverses the image so that it is finally printed in the same direction as it was originally drawn; but the main advantage is commercial, in that it enables the printing to be done by a series of rollers which enormously speeds the operation. This has made the traditional flat-bed lithographic press obsolete for all except artists' prints. New developments in offset lithography during the past two

90 The original stone from which **89** was printed (reduced). Since this impression was printed, the stone has been cancelled.

decades have also made traditional letterpress printing obsolete, and almost all books (including this one) are now printed by offset.

Instead of drawing directly on the stone, the artist can use transfer paper. This is a sheet of paper which has been covered with a soluble surface layer. The artist draws on this surface with a greasy medium; the transferring is done by placing the paper face downwards on the stone and moistening it until the soluble layer dissolves and leaves the greasy drawing adhering to the stone. Prepared transfer paper can be purchased with various grains and textures. Its advantages are in ease of transport and the fact that the image is automatically reversed so that the final result is in the original direction; moreover the transferred image can easily be reworked on the stone. But the disadvantages are serious; the stone allows much more varied styles of drawing than the paper, and some of the image is always lost in the transfer. A transfer lithograph can usually be distinguished from one drawn directly on

Edouard Manet *Under the lamp*,
1875. Wash lithograph (greatly
reduced).

the stone by the loss of definition and the tell-tale reproduction of
the grain of the paper.

A further use of transfer paper is that a relief or intaglio print can
be printed on to it in a special greasy ink, and then be transferred
from the paper to a stone. This was much used from about 1850 for
commercial printing (and by one original artist, Rodolphe Bres-
din), and explains how, for example, an engraving can appear to be
lithographically printed. This technique can also be used to
transfer a lithographic image on to more than one plate in order to
speed printing.

A lithograph has no plate-mark of the sort shown in an intaglio
print, but the area which has been flattened in the press can
sometimes be made out. The ink lies flat on the paper, and can often
be seen under magnification to be broken. A lithograph cannot
really be confused with any print produced by one of the non-
photomechanical processes, but can very easily be confused with a
photolithograph.

Lithographic stones or plates in general yield a fairly large
number of impressions without deterioration, but much depends on

the quality of the surface, the method of drawing, the delicacy of the work and the skill of the printer. A relatively coarse image can be printed indefinitely. A stone can be re-used by grinding down the surface and removing all trace of the previous image.

Historical When lithography was invented in 1798 in Munich by Alois Senefelder, it was the first entirely new printing process since the discovery of intaglio in the fifteenth century. Senefelder himself originally developed it as a means of printing music more cheaply than by engraving, but, realizing its potential for other uses, went into business with various partners to operate lithographic presses in the capitals of Europe. The full commercial impact of lithography was, however, delayed for twenty years, partly through Senefelder's lack of business acumen, and partly because of the numerous technical difficulties which had to be overcome. In these early years there is little to be found in France, and in England only the interesting series entitled *Specimens of Polyautography*, containing lithographs by many well-known artists of the day, which lasted only from 1803 to 1807. The main centre of lithography was naturally in Germany; it was there used in several weighty publications reproducing paintings in public galleries, as well as by such leading artists as Karl Schinkel and Ferdinand Olivier.

The end of the early period of lithography came in 1816, when Godefroy Engelmann moved his press from Mulhouse to Paris. Within a few years lithography was taken up enthusiastically by many leading French artists, and some of the great masterpieces of the medium were made by Théodore Géricault and Eugène Delacroix. A parallel growth of interest in England followed Charles Hullmandel's establishment of his own printing shop in 1818, and it was in fact Hullmandel who printed Géricault's so-called *English Set* in London in 1820. The enormous production of lithographs in this period falls into several well-defined categories. Most important was the topographical tradition. In France a new school of romantic landscape lithographers such as R. P. Bonington, Eugène Isabey and Paul Huet, grew up around the vast publication of Baron Taylor, the *Voyages Pittoresques et Romantiques dans l'Ancienne France*, which began in 1820 and was not abandoned until 1878, while in England lithography supplanted aquatint as the preferred medium for large colour-plate books. In France the other main traditions were of scenes from the Napoleonic legend (by Carle and Horace Vernet, Nicolas Charlet and Auguste Raffet); social and political satire (by Gavarni and, above all, Honoré Daumier); and the flourishing academic school of reproductive lithographers who provided the staple fare for the lithography section of each annual Salon.

In the rest of Europe lithography flourished less spectacularly.

DAS SCHLOSS PREDIAMA IN CREIN XII STUND: VON TRIEST.

Two remarkable artists however must be mentioned. The first is Goya, who, having made a few experiments in Madrid in 1819, returned to lithography in 1825 at the age of seventy-nine, when in exile in Bordeaux, where he produced the famous set of four scenes of bull-fights known as the *Bulls of Bordeaux*. The other is the great German painter and illustrator Adolf Menzel (1815–1905), whose chalk and wash lithographs, which often make remarkable use of scratching out, deserve to be better known.

In France and in Britain the impetus that lithography had received in the 1820s had begun to languish by the middle of the century; in the commercial field it was rapidly gaining an unassailable pre-eminence, but few artists were paying it much attention. The most interesting of these was the isolated and eccentric Rodolphe Bresdin, who meticulously drew on the stone in the same way as he drew on paper. An abortive attempt in 1862 by the publisher Cadart to produce a portfolio by several artists inspired Edouard Manet to make a handful of superb prints in the years before 1875, but it was not until that decade that the main revival really began, when Henri Fantin-Latour and then Odilon Redon turned to lithography. The extraordinary popularity of colour lithography in the 1890s, which is described in the section on colour printing, had a different origin in the sudden fashion for posters; it also indirectly inspired a further interest in black and white lithography among artists like Camille Pissarro and Edgar Degas. A parallel development in England started with Whistler, whose long series of chalk and wash lithographs begins (excepting a few prints of 1878–9) in 1886.

In the years around the turn of the century the most interesting European lithographs were made by Edvard Munch and the German Expressionists; in particular E. L. Kirchner hand-printed his plates to produce a range of most unconventional and exciting textures and effects. In these years attention in France and England was mainly focused on the intaglio and relief processes, but the Americans took up lithography with enthusiasm. This school, although still little known on this side of the Atlantic, produced some remarkably interesting prints. The best were by George Bellows (1882–1925), whose mastery of chalk and wash has rarely been equalled. His subjects cover a remarkably wide range, from dynamic boxing fights, to gruesome madhouse scenes and humorous, almost satirical depictions of aspects of American life.

Since the Second World War lithography has experienced its greatest popularity since the 1820s. Picasso led the way with a series of splendid prints printed by Mourlot in Paris from 1944 onwards, and dealers were soon commissioning more from all the leading European artists. Interest in America can be traced to the foundation of several specialist lithographic workshops, notably Universal Limited Art Editions in New York in 1957 and Tamarind

92 Karl Friedrich Schinkel *Das Schloss Prediama in Crein*, 1816. Pen lithograph (greatly reduced).

93 *left* Adolf Menzel *The captives' journey through a wood*, 1851. Chalk and wash lithograph with much scratching out (actual size).

94 *above* Ernst Ludwig Kirchner *Hugo lying at table*, 1915. Chalk lithograph (greatly reduced).

in California in 1960. Some of the leading post-Abstract Expressionist painters, in particular Jasper Johns and Robert Rauschenberg, made many original and very successful prints, and inspired a lithographic fervour which has only abated in the mid-1970s. Similar efforts in Britain have been centred on the Curwen Studio.

Screenprinting

Technique Screenprinting is a variety of stencil printing. A gauze screen, fixed tautly on to a rectangular wooden frame, is laid directly on top of a sheet of paper. Printing ink is spread over the upper side of the mesh and forced through it with a squeegee (a rubber blade) so that the ink transfers to the paper on the other side. The material of the screen is usually silk (Americans call the process *silkscreen* or occasionally *serigraphy*), but can be cotton, nylon or a metal mesh.

The design is applied to the screen in various ways. The earliest technique was simply to cut out a masking stencil of paper and attach it to the underside of the screen; another simple device is to paint out areas of the screen with a liquid that sets and blocks the holes in the mesh; but there are numerous other ways of masking that can be used to produce different effects. One important development is the use of photo-stencils, which allow the artist to incorporate photographic images into the print. The screen is coated with bichromated gelatine and placed in contact with a photographic negative or diapositive. Light is then shone through the transparency on to the gelatine, which hardens under exposure but remains soft where protected by the black areas of the transparency. When the exposure is completed, the soft areas can be washed away with warm water, leaving the hard exposed gelatine to act as a stencil.

Artists' screenprints have almost always been printed in colour. Since a single screen cannot easily be inked in more than one colour, this is usually done by successive printings, using a different screen for each colour.

A screenprint can usually be distinguished from a lithograph (the process most similar to it) by the wove pattern of the screen which is impressed into the surface of the ink. Compared with other printing processes, it is relatively crude, since the mesh of the screen does not allow much fineness in drawing. This has been overcome to some extent by using photo-stencils, which break down images photographically by means of a half-tone screen (see p. 123) into gradations of tone. On the other hand, screenprinting deposits a much thicker charge of ink on to the paper than other methods, and this produces a richer impasto and a more vivid range of colour.

Historical The origins of screenprinting are lost in the unexplored murk of the history of commercial printing. Stencils have been used from ancient times for lettering and for labelling objects, but the technique of attaching them to a gauze mesh seems to have been developed in Japan and brought from there to Western Europe in the late nineteenth century. It was rapidly adopted for use in advertising, packaging and labelling and machines were patented for high-speed printing through stencils. The photo-stencil process came into use around 1916.

95 *opposite* R. B. Kitaj *Addled Art*, 1973. Screenprint (greatly reduced).

VOLUME VI

Minor
Works

EDITED

Georges
BERNANOS

ADDLED
ART

MINOR
WORKS

ADDLED ART MINOR WORKS VOLUME VI

Given such humble origins and the relative crudity of the images it can produce, it is not surprising that artists did not immediately think of exploiting screenprinting for their own purposes. The earliest attempts appear to have been made in America in the Depression of the 1930s largely because of the cheapness and ease of the process; the best known prints of the following years are by Ben Shahn and by Jackson Pollock, who made a few around 1951. But collectors and dealers were even more prejudiced against it than many artists, and it was not until the 1960s that the prejudices began to break down with the realization that some of the best modern prints were screenprints.

This change of attitude has not yet found an historian, but one of the most important stages in it was the founding by Christopher Prater of the Kelpra Studio in London. A project by the Institute of Contemporary Arts in 1962 to commission screenprints from many of the leading British artists succeeded beyond all expectation, and fired the enthusiasm of, most notably, Eduardo Paolozzi, Richard Hamilton and an American expatriate, R. B. Kitaj. A parallel development in America introduced the process to many of the leading Pop artists, including Andy Warhol and Roy Lichenstein. Warhol and Robert Rauschenberg have in fact extended its use by printing screenprint elements on to canvas as the basis for many paintings.

Two possibilities of screenprinting in particular have appealed to many artists. The fact that it can print flat, unmodulated and sharply defined areas of colour has attracted hard-edged abstractionists; even more important is the possibility of incorporating photographic imagery, which has proved ideally suited to the Pop artists' and others' preoccupation with the psychological and aesthetic aspects of standard commercial or political imagery. By using screenprinting, itself a commercial medium, they have managed to capture the rawness of effect of the original imagery while at the same time manipulating the viewer's responses by putting it into a fine art context. But printmakers striving for autographic qualities find that the medium has little to offer them.

The success of screenprinting has been only one aspect of the remarkable development and popularity of printmaking since the end of the Second World War, and it may be worth considering some of the factors which lie behind this. The traditional connoisseur's approach to prints collapsed with the market in 1929, and took with it his accumulative zeal and prejudices about states and other minutiae. The Post-War print has been purchased by a wider non-specialist clientèle primarily for room decoration, and has therefore been larger and more highly coloured than its predecessors. This has opened up new fields and made prints more interesting for the painter. But all this was true in the 1950s; the special importance of prints in the 1960s was due to the fact that the

medium was taken up by the best painters of the period, and, as is almost invariably true, it is the best painter who is the best printmaker. The reason why printmaking then became of such interest to artists lies in the reaction of the 1960s against the overwhelming success of Abstract Expressionism. To escape from its personalized gestures, artists introduced a wide range of figurative subject-matter, and a new preoccupation with process and the way in which the medium imposes its discipline on the subject. In this exploration the lithograph or screenprint is quite as significant as a medium as the painting. In consequence printmaking, as a category of artistic production, has been elevated to a status and importance in the more general history of art which it has only rarely attained before.

Colour Printing

There is an important distinction to be drawn between *colour* prints and *coloured* prints. A *colour* print has actually been printed with inks of different colours; a *coloured* print is printed in ink of one colour and has had extra colouring added by hand. This chapter is mainly devoted to colour prints, and since the techniques of colour printing are dependent upon the printing method employed, they are described under the categories of relief, intaglio and lithography; colour screenprints have already been discussed in the section devoted to screenprinting.

Hand-coloured prints greatly outnumber colour prints, and it is worth introducing this chapter with a note on this subject. Since colour now has a more ready market than black and white, many old prints have during this century been coloured by dealers before being offered for sale to the public. This practice has dismembered thousands of books and ruined many fine prints, and is quite indefensible because it destroys the tonal balance of black and white with which the print was conceived. There were however certain classes of print that were regularly coloured before or soon after publication, and these can be described briefly.

Fifteenth-century single sheet woodcuts (though rarely engravings) were often coloured; this suited their function as images of popular piety and devotion whereas engravings were aimed at a more sophisticated market. Similarly, many fifteenth-century north European illustrated books were hand-coloured: for example, documents show that the publishers of Hartmann Schedel's *Liber Cronicarum* (Nuremberg, 1493) distributed both plain and coloured copies to their retailers. Colouring in this period was sometimes done through specially cut stencils, which can often be recognized by a contour which is out of register with the lines of the design.

Although the more popular woodcuts and broadsheets were still coloured, in the sixteenth and seventeenth centuries the number of hand-coloured prints greatly declined, largely as a result of the new dignity that Dürer had conferred on the woodcut, but also because woodcut was giving way in popularity to the intaglio print, which was rarely coloured. The major exceptions are certain categories of books, especially botanical and zoological works, in which much of the essential information could be conveyed only through colour.

The situation changed considerably in the second half of the eighteenth century. One entirely new use of colouring was devised. The popularity of large watercolour views and the practice of making replicas of successful compositions gave some watercolourists the idea of saving time and trouble by making their watercolours over lightly etched outlines. This was most highly developed in Switzerland by artists such as J. L. Aberli (who took out a patent for the method in 1766) and J. J. Biedermann, whose principal market was the foreign tourist, but was taken to Italy where it was practised by L. J. Desprez, a French draughtsman who

worked with Francesco Piranesi in Rome, and Abraham Ducros who coloured outline etchings by Giovanni Volpato.

More traditional types of hand-colouring also returned to favour. Their most widespread use was made in England, where categories of prints such as satires and many single-sheet topographical views were regularly sold already coloured. Aquatints especially lent themselves to this, and the development of that uniquely English phenomenon, the colour-plate book, was based on the existence and capabilities of teams of trained colourists. The colourists were often helped by printing the aquatint plates in two colours, *à la poupée* (see p. 118): the skies and distances were printed in pale green/greenish-blue, while the foregrounds were in brown. The fashion for colour-plate books lasted into the nineteenth century, when lithography was used as well as aquatint to supply the underlying design, but petered out in the 1830s. The Victorians loved colour, but their publications were, instead of being hand-coloured, almost invariably printed in colours.

A coloured print may readily be distinguished from a colour print. Under a magnifying glass it will be seen that the lines of ink of the latter are themselves coloured, while white paper may be seen between them. In a coloured print the lines will usually be in a different colour from the overlying wash which will stain the areas of unprinted paper. It should, however, be noted that prints printed in colours were very often given extra finishing touches of hand-colouring. A more difficult problem is to distinguish modern from original hand-colouring. Sometimes the identification of the class of print will answer the question; for example nineteenth-century engraved English topographical views in books were never issued already coloured. More often a judgement is impossible without familiarity with genuine examples. A few rules of thumb may be given. Before about 1760 original colouring is usually bold and gaudy and applied in a slapdash manner. It is often opaque and completely obscures the lines of the design; modern colouring on such prints, being invariably in watercolour, never does this, and tends to be more carefully applied, with the result that it usually looks timid and anaemic. After 1760 standards of colouring greatly improved, and the distinction is more difficult to make.

Colour Woodcut

It is unusual to ink a woodblock in more than one colour. To print a colour woodcut normally as many blocks are used as there are colours (except in so far as new colours are created by overprinting other colours). The usual method is to make a *key-block* with the design in outline. Impressions from this are then hand-coloured, each with one of the colours required in the final design; these sheets are pasted on to other blocks from which the woodcutter cuts away all the non-printing areas. Each block can

then be inked in its appropriate colour and printed successively on to the same sheet of paper. In this care has to be taken that each block prints in register with the others.

There are various ways in which the artist can handle the colour woodcut. The most obvious perhaps is the way of the Japanese; areas of pure colour are juxtaposed with extraordinary decorative effect. It is curious that this technique was hardly practised in Europe before the discovery of the Japanese print in the late nineteenth century. The traditional type of western woodcut, often known as a 'chiaroscuro' woodcut, was produced in imitation of a monochrome drawing made on tinted paper and heightened with white bodycolour. Thus the inks were often shades of the same colour, and the blocks were cut in such a way that areas of white paper were left amid surrounding colour in imitation of the effect of the heightening on the drawing.

One of the earliest uses of colour in woodcuts is found in a few books printed by Erhard Ratdolt in Venice in 1482. The first experimental single sheet colour woodcuts, where highlights are added in colour, were made in Germany by Lucas Cranach and Hans Burgkmair in 1507–8. By 1510 they had developed this into the true chiaroscuro technique in which the highlights are cut out of the block. The technique remained fairly popular in the North for over a century. It was used by Hans Baldung Grien and Hans Wechtlin, and spread from Germany to the Netherlands. The finest prints were made by Hendrik Goltzius in the 1580s and 1590s, but its use continued into the seventeenth century with Ludolph Businck (1599/1602–1699), Christoffel Jegher (two of whose woodcuts after Rubens had colour-blocks added) and ends with one by Jan Lievens.

The medium found much greater popularity in Italy, where Ugo da Carpi petitioned the Venetian Signoria for a copyright in 1516. Whereas the Germans had tended to use the colour-blocks as decorative adjuncts to a design already completely defined by the key-block, the Italians were bolder and so limited the key-block that the design would be unreadable without the addition of colour-blocks. By this device the medium could be used to make a convincing facsimile of a wash drawing which made little use of line. The chiaroscuro woodcut was used as a means of dissemination by many of the leading Italian artists; Ugo da Carpi worked for Raphael and Antonio da Trento for Parmigianino, while Domenico Beccafumi himself made seven remarkable cuts. It retained its popularity into the seventeenth century, and came to an end with the works of Andrea Andreani (d. 1623).

In the 1720s the technique was revived in Venice in an antiquarian spirit by Count Antonio Maria Zanetti to reproduce various Parmigianino drawings which he had acquired in London. It was similarly used in Paris by Nicolas Le Sueur for a few plates in the large two-volume series of reproductions of drawings in the

Crozat collection (1729 and 1742), and in England by John Skippe in the 1780s. An original variety of colour woodcut was developed by the Englishman John Baptist Jackson, who trained in Paris, but published all of his prints in Venice between 1731 and 1745. His woodcuts are reproductions, not of drawings, but of paintings or gouaches, and so are handled quite differently, with areas of strong colour built up with heavy relief from as many as six blocks.

Woodcut tone-blocks could also be used to supply colour to a design printed by some other method. This can already be found in the sixteenth century when blocks were occasionally printed over etched outlines, and became quite popular in the eighteenth century as a method of making facsimiles of Old Master drawings. It seems to have been popularized in England in 1722–4 by Elisha Kirkall, who printed the woodblocks over a mezzotint foundation, though his English followers, Pond and Knapton, like Le Sueur in many of his prints in France, preferred to stick to etching. The same procedure was used to quite a different effect in the nineteenth century when George Baxter and his licensees built up their highly coloured miniature paintings from numerous woodblocks printed over an engraved or etched foundation. Edmund Evans, in his famous series of children's books illustrated by such artists as Kate Greenaway, used blocks to print flat tints of colour over a wood-engraved design.

The vogue for Japanese woodcuts in the late nineteenth century attracted renewed attention to the medium, and showed artists that it was not necessary to confine the use of the technique to reproducing drawings. The first to realize this was Paul Gauguin, but the most extraordinary technique was developed by Edvard Munch in the 1890s. He began by using whole planks of pine, scraped down with a blade or a wire brush to emphasize the grain, to print richly-textured backgrounds. He then cut a single block into pieces around the main shapes of the design, which he coloured separately and rejoined for printing. Such colour woodcuts were often experimentally overprinted lithographically with other colours to produce a new range of effects.

When Picasso took up linocut in the late 1950s, he adopted and popularized another way of making a colour relief print. This is sometimes known as the 'reduce block' method, and involves successive printings from the same block onto one sheet. The lightest tones are printed first, then these areas are cut away before printing the middle tones (which will overprint and obliterate some of the lighter areas); finally the block is still further reduced and the darkest colours printed. This process may of course be repeated indefinitely as long as each new colour is sufficiently opaque to cover the previous colours.

117

Colour Intaglio Printing

There are two traditional ways of colour printing from intaglio plates. Either a single plate is selectively inked in different colours, or the image is built up from separate plates for each colour.

The first method is often called by its French name, *à la poupée*. It requires very considerable skill and artistry on the part of the printer, who has to press the ink into the lines of the plate using stumps of rag (a 'dolly', or *poupée*), and then wipe the surface, taking extreme care not to smudge the colours. No two impressions printed in this way can be expected to be exactly similar, and such prints were usually retouched by hand.

The multiple-plate method relies less on the skill of the printer, who has only to print the plates in correct register, but is more laborious both in the preparation of the plates and in the repeated printing operations. The trickiest part is the exact registration of the plates. One method of securing this is to drill holes in the same position on each plate and line up plates and paper with pins; the round marks from these holes are often visible on colour prints and are a certain indication of the multiple-plate method.

A third method of colour printing which uses inks of different viscosities was developed by S. W. Hayter in Paris in the 1950s. Inks of varying viscosity will not settle if applied one above another, and this discovery can be used to print in more than one colour from a single plate bitten to different depths (see his book, *New Ways of Gravure*, London, 1966).

(a) Printing *à la poupée*

The earliest sort of colour printing involved inking plates in a monochrome but coloured (i.e. not brown or black) ink, or printing plates on to a sheet of coloured paper. Examples of this occur sporadically through the history of engraving, the best-known being the etchings of Segers. Etched and engraved plates however look very odd if the lines are inked in different colours, and the only artist who is known for such experiments is Joannes Teyler of Haarlem, who lived in the late seventeenth century. The technique is also found in a few natural history works with etched plates.

The full development of colour printing had to await the invention of the tonal processes. As developed in France it was closely tied to the multiple-plate method, but single plate printing of designs in mezzotint was already practised in Britain in the 1720s by Elisha Kirkall, and became very common with stipple and mezzotint plates in the later eighteenth and early nineteenth centuries. The standard editions of these plates were usually printed in monochrome (the stipples often in sepia), but a few early impressions were run off in colours for wealthy buyers. This was particularly true with stipples which were intended for framing;

118

among mezzotints female portraits were occasionally colour printed, but more often this was reserved for 'fancy', pastoral or agricultural subjects. Publishers seem also to have resorted to colour printing as a way of disguising wear in a plate which would be more obvious in monochrome. This was often done in nineteenth century reprints of earlier plates. Colouring *à la poupée* is sometimes also found in French stipples, and on a few closely worked etchings emanating from the circle of the Piranesi family in Rome.

(b) Multiple-plate printing

If we ignore a few rare prints by François Perrier (1590–1650), in which etching is overprinted in white ink, the earliest multiple-plate method, using plates worked in mezzotint, was invented by the German Jakob Cristof Le Blon (1667–1741). Applying Newton's theory of colour, he hoped to be able to produce accurate facsimiles of oil paintings by scraping a separate mezzotint plate for each of the three primary colours, blue, yellow and red. Although this is indeed the same principle as is used in modern three-colour process printing, Le Blon's prints never really succeeded, partly because of the impossibility of separating out the colours by eye, and even more because of the impurities of the pigments in his printing ink. The company Le Blon founded in London to exploit the process in 1720 went bankrupt in 1732, and he spent the last years of his life in France, where he obtained a patent from Louis xv. After his death a new patent was issued to his former assistant Jacques Gautier d'Agoty for what was effectively the same process with the addition of a fourth black plate, and members of the d'Agoty family continued using the technique to the end of the eighteenth century. Although none of their prints, with the possible exception of a set of lurid anatomical plates, are much more than curiosities, they do seem to have been responsible for implanting the tradition of multiple-plate colour printing firmly in France.

A renewed interest in colour printing followed the development of so many new techniques in the mid-eighteenth century. Some of the earliest were the sets of flower prints made in about 1770 by Anne Allen after drawings by her husband, J. B. Pillement. These are most unusual in being multiple-plate printed outline etchings, but had apparently no successors, probably because the riot of colours pursuing each other over the page could only work on such highly decorative subjects.

Another development was the *pastel-manner*; this was simply an adaptation of the crayon-manner for colour printing by Louis-Marin Bonnet, who announced his invention in 1769. He used it in general to imitate the effect of drawings *à trois crayons*, using a different plate for red, blue and white, but in one famous print, the *Tête de Flore* after a pastel of Boucher, he used as many as eight plates on tinted paper. Bonnet was followed by Gilles Demarteau,

but the process fell out of fashion with the eclipse of crayon-manner at the end of the century. The only apparent development out of it is found in the puzzling facsimiles of Old Master drawings by Ploos van Amstel (1726–98), but the secret of their techniques died with their inventor.

The invention of aquatint and a variety of aquatint-like processes in the late 1760s inevitably led to attempts to harness these techniques to colour printing, and the great masterpieces of French colour printing were in fact made by these methods. The pioneer was Jean-François Janinet, a pupil of Bonnet, in the 1770s; he used it to reproduce, not chalk drawings, but watercolours and gouaches, and the flat, crisply defined areas of colour that aquatint gives proved ideal for this. The greatest master of the technique was, however, Philibert Louis Debucourt (1755–1832), one of the most gifted engravers of all time. The fifty-six prints of his best years between 1785 and 1800 are all after his own designs, and give a wonderful view of the closing years of the *Ancien Régime* and the period of the Directory. He seems to have used at least ten different methods, most of which involved three colour plates (red, yellow and blue) with a fourth plate giving the key design printed on top in black. The process fell into disuse after 1830, but was revived in 1891 by Mary Cassatt in a set of ten plates 'in imitation of Japanese methods'. With the popularity of colour prints in general in the years around 1900, colour aquatint was much used by professional reproductive engravers.

Colour Lithography

Since a stone, like a woodblock, can only be inked easily with one colour, colour lithography usually employs as many stones as colours, although extra colours can be created by overprinting. The artist usually first makes a preliminary sketch of his composition, and from this draws on to a key-stone. Impressions pulled from this stone serve to transfer the image to the colour-stones, on which the areas of each colour are drawn in. Finally the stones are inked with the desired colours, and are successively printed on to the one sheet of paper. Great care is needed both in the order of printing the colours and in the exact registration of the paper on the stones. This is often done by sticking a pin through the paper and inserting it into holes drilled at the same point in each stone. Such pin-holes can often be seen on the edges of lithographs.

The earliest use of a second stone in lithography was to supply a background colour; this was called a tint-stone and had the highlights scratched out. Full colour lithography came later. In 1837 Engelmann was granted a French patent for a process which worked on Le Blon's principle of using one stone for each of the primary colours. More effective and influential was the alternative method of Hullmandel in London, which used a different stone for

1 opposite above Anonymous, *The Infant Christ amid flowers*, German, *c.* 1460. Woodcut with contemporary hand-colouring (slightly reduced).

2 below Johann Jakob Biedermann *View of the city of Bern* (detail), *c.* 1800. Hand colouring over an etched outline (actual size).

3 Ugo da Capri
after Parmigianino
Diogenes (detail),
c. 1527/30.
Chiaroscuro
woodcut printed
from four blocks
(reduced).

4 Hendrik Goltzius
*An Arcadian
landscape*, 1580s.
Chiaroscuro
woodcut printed
from three blocks
(greatly reduced).

5 John Baptist
Jackson after Marco
Ricci *Landscape with
an obelisk* (detail),
1744. Colour woodcut
printed from perhaps
six blocks (reduced).

6 George Baxter *The
Belgian section in the
Great Exhibition*
(detail), 1852. Printed
from one intaglio
plate and ten
woodblocks (reduced).

7 John Jones after George Romney *Serena*, 1790. Stipple printed with colour
applied to the plate *à la poupée* (greatly reduced). See **71** for an enlarged
detail of an uncoloured impression.

8 Philibert-Louis Debucourt *Les Bouquets ou la fête de la grand-maman*, 1788
(reduced). Printed in colours from four plates engraved with roulettes, etc.;
the effect is similar to aquatint.

9 left Jakob
Christoph Le Blon
after van Dyck *Self-
portrait*, 1720s.
Mezzotint printed
from three plates
(greatly reduced).

10 right Pierre
Bonnard *Coin de
rue*, 1895. Colour
lithograph (greatly
reduced).

11 Thomas Shotter
Boys *Notre Dame,
Paris* (detail), 1839.
Colour lithograph
(greatly reduced).

12 Eduardo Paolozzi *Metalization of a dream*, 1963. Screenprint (greatly reduced).

Colour Intaglio Printing

each colour. The first great work in this process was Thomas Shotter Boys's *Picturesque Architecture in Paris, Ghent, Antwerp, Rouen*, published in 1839. The high Victorian period saw a great flood of colour lithographs, reproductive in intention, mainly for book illustrations or handsome portfolios. These were called chromolithographs and were printed with immense skill: a design of apparently eight or ten colours will often be printed from no less than twenty stones. 'Chromolithograph' only began to be a term of abuse when, in the 1890s, a group of young French artists were inspired by Japanese prints to make colour lithographs using flat tints with a superbly decorative sense of design. The great masters of this were Henri de Toulouse-Lautrec, Edouard Vuillard and Pierre Bonnard, and the impetus for their interest in the medium seems to have been given by the popular success of the large commercial posters of Jules Chéret.

Since the turn of the century most artists who have turned to lithography have as readily made colour as black and white prints, and as a result colour lithography ceases to have a separate history.

Photomechanical Reproduction Processes

Photography was invented in the 1820s, but it did not immediately revolutionize the print trade. A way had first to be discovered to enable the photograph to be multiplied for mass production, whether as single sheet prints or as book illustrations. Of course multiple photographic positives could be printed from any negative and could be (and often were) stuck into books, but this was slow and expensive, quite apart from the disadvantage, which was not overcome for a long time, that the photographs were inclined to fade.

Many of the photomechanical printing processes are based on Poitevin's discovery in 1855 of the sensitivity to light of bichromated gelatine. This hardens when exposed to light, but where shielded from light remains soft. The other development crucial to many of the processes was the half-tone screen, which can break up a tonal image into a mass of dots. There were numerous initial technical problems in applying these discoveries, and it was not until the 1890s that photomechanical processes finally ousted the traditional ones for all except artists' prints.

The various methods can conveniently be classified according to the method of printing. Two oddments, the autotype and the woodburytype, are described in the glossary.

Processes of Relief Printing

Line-blocks and half-tone blocks The traditional method of block making was developed from the gillotage process (see glossary). A zinc plate is coated with bichromated albumen or some other light-sensitive material. This is exposed to light under a high-contrast negative; the plate is then rolled over with ink and the soft unexposed albumen washed away. The plate is next dusted with a powder which adheres only to the tacky ink and which is heated to form a resist; thus the background of the plate can be etched down to leave the lines of the design standing in relief, protected by the resist. The etching process has to be repeated four times, each time strengthening the sides of the lines with further applications of resist powder. The plate is then cleaned and may by used for printing in any relief printing press. This traditional process has, however, been completely superseded since the Second World War by electronic scanners and automatic etching machines.

The line-block is simple to produce but is severely limited in that it can only reproduce line or granular originals. Printing only blacks, it cannot handle transitions of tone in grey; in these cases the half-tone block has to be used.

The appearance of a line-block is similar to that of a woodcut and a wood-engraving. When it has been used to make a facsimile of a woodcut or wood-engraving, comparison with an original will show that the reproduction has a greater regularity and hardness of line. In nineteenth-century book illustration, however, stereo-

types or electrotypes were normally used rather than the original wooden blocks, and in these cases it can be almost impossible to tell whether an electrotype or a line-block has been used.

The half-tone block is simply a version of the line-block used in cases where the original to be reproduced shows transitions of tone. The procedure adopted is to photograph the original through a cross-line screen of parallel horizontal and vertical lines to produce a negative composed of lines of dots of larger or smaller size depending on the intensity of tone in the original. This negative is then used to make a block in the same way as with a line-block. The purpose of this procedure is to break up a tonal original into a series of black dots so that it can be turned into a relief block; yet the dots are so small that they are individually invisible to the human eye, except under magnification. They are instead perceived as greys, in the same way as the eye perceives the lines on a television screen as a continuous tonal image.

Half-tone relief blocks have one complication. It will be obvious that the closer the mesh of lines on the screen, the greater will be the accuracy of detail. But if a very fine screen is used (one hundred and fifty lines or more to the inch), the resulting dots are so tiny that they can only be printed successfully on absolutely smooth paper. This explains why newspapers, which have to print on coarse newsprint, are forced to use wide-mesh screens, while the high-quality plates in books are always printed on a special glossy chalk-coated 'art' paper. (This is however not necessary with half-tone offset lithography – the method used to illustrate this book).

96 Macrophotographic enlargement showing the dots of a half-tone.

A half-tone print is always easy to recognize; under a magnifying glass the mesh of dots will become clear.

The line block was developed in the 1870s and was an efficient commercial process from about 1880. By the 1890s it was so well established that an artist like Aubrey Beardsley was producing pen and black ink drawings designed specifically to be reproduced as line-blocks. The idea of using a screen has a long pre-history reaching back to Fox Talbot in 1852, but the first commercially successful use was patented in Germany and Britain in 1882 by Georg Meisenbach. With various later improvements, the process by 1890 was substantially as described in the first paragraph above. Because line and half-tone blocks can be printed together with type, they account for the great majority of book illustrations of the past century.

Processes of Intaglio Printing

The two processes described here are both usually called simply photogravure; this causes much confusion as their appearance is very different. The terms adopted here are not always used, but there is no obvious alternative.

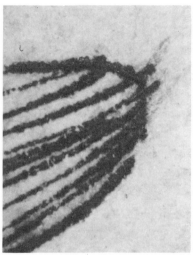

97 *top* Macrophotographic enlargement of the right outermost wing-tip seen in **32**; an ink smear caused in wiping can be seen. **98** *bottom* is an enlargement of the same detail in a facsimile made by the hand photogravure process. The accuracy is remarkable, but the lines are less distinct and the effect (in the original at least) is flatter.

1. Hand Photogravure A sheet of bichromated gelatine is placed in contact with a negative and exposed to light; in proportion to the strength of transmitted light the gelatine hardens. The sheet of gelatine is then transferred to a copper plate which has previously been given an aquatint ground. The soft gelatine is washed away and the plate etched, the remaining gelatine acting as a weak resist; the acid bites into the plate through the different levels of gelatine to different depths, while the aquatint ground serves the same purpose as a screen in allowing the reproduction of tone. The etched plate is finally cleaned of gelatine and is hand-inked, wiped and printed in exactly the same way as an ordinary intaglio plate.

This lengthy method of printing ensures that hand photogravure has no wide commercial application; it is in fact hardly used now. In the later nineteenth century, however, it was very widely employed for high quality, expensive single sheet prints which were published in exactly the same way and by the same dealers as engravings, and it was this process that drove the reproductive engravers and etchers out of the market. It gives very accurate reproduction of tone, and can be easily recognized since it is the only photomechanical process to leave a plate-mark. The preparation and etching of the plate was a skilled business and there was considerable scope for sharpening or otherwise adjusting the final image with retouchings made with burins, roulettes and the other tools of the printmaker. In fact a few artists seem to have been in the habit of making original prints by reworking photogravures; one famous example is Georges Rouault's *Miserere* series. The craftsman who prepared a plate usually had his name engraved underneath the image, followed by the word *photosculpsit*, sometimes abbreviated to *Ph. Sc.*

This process may also of course be used to reproduce line work, in which case the aquatint ground is unnecessary. It produces the most accurate facsimiles obtainable of an engraving or an etching. Because it is an etching process the line can usually be distinguished from an engraved original, but if the original is itself an etching the reproduction is difficult to tell apart except by close comparison with an impression of the original. Many reproductions are identified by stamps on the verso; one frequently met is on the facsimiles published by Amand-Durand in Paris between 1872 and 1878 (see margin, right).

The earliest version of hand photogravure was patented by Paul Pretsch in 1854; his Photogalvanographic Company began production in 1856 but went out of business within a few years. Commercially more successful were various rivals active from the mid-1850s in France, where the name applied to their process, heliogravure, is still used. The standard process was perfected by Karl Klić in 1879 and soon superseded the earlier methods.

99 Macrophotographic enlargement showing the grid of machine photogravure.

2. Machine Photogravure The process is in essence the same as that for hand photogravure. The major difference is that the tone is supplied not by an aquatint ground but by a cross-line screen printed onto the gelatine. When the gelatine is etched down this screen stands in relief on the plate. This allows the plate to be inked and printed mechanically: the surplus ink is wiped off the surface of the plate and the paper picks up the ink from the cavities. Although technically intaglio-printed, the pressure is not such as to leave a plate-mark.

This process has had a very wide commercial application, particularly when it was discovered that the plate could be bent into the form of a cylinder. This development, which allows very fast printing speeds, is known as rotogravure. The complicated nature of the process needed to manufacture the printing cylinder makes it economically efficient only in printing runs of over 100,000, and it is now usually used for things like magazines and catalogues rather than books. The type is photographed and printed from the same cylinder as the picture.

The grid of the photogravure screen usually prints white; in the shadows, however, it disappears completely, and in this is unlike the half-tone screen, where the dots of white simply become smaller. It was developed from hand photogravure by Karl Klič in 1890 when he substituted the cross-line screen. He began the first commercial application of the process in 1895, but it was kept secret, so that it had to be re-invented by others in the years immediately after 1900. It deposits a thick charge of ink onto the paper and can thus give a greater range of tone than any other photomechanical process except collotype. It is unfortunate that the expense precludes its greater use for black and white illustration; examples are now normally only seen in books printed abroad, especially in France.

Processes of Surface Printing

1. Photolithography In the nineteenth century various methods of making photolithographs were used. Most were based on the discovery in 1855 of the light-sensitive properties of bichromated gelatine. As in relief printing, the early methods would only produce line or granulated work, and were largely used to reproduce maps and manuscripts. The possibility of reproducing tones had to await the invention of the half-tone screen in the 1880s.

Early photolithographs are in appearance very similar to ordinary lithographs. When the process is used to make a facsimile of a lithograph, the result can be very deceptive and can only be distinguished from the original by close comparison. In the same way it will produce deceptive facsimiles of original drawings of a granular texture. Photolithographic lines and half-tone dots have

softer edges and are less sharply defined than those printed by letterpress. As offset lithography has superseded traditional letterpress in recent years, so photolithography has greatly increased in importance.

2. Collotype A surface (usually a sheet of heavy plate glass) is coated with light-sensitive gelatine and exposed to light under a photographic negative. In proportion to the strength of transmitted light the gelatine dries and hardens, while in the unexposed areas it remains capable of absorbing moisture. The surface can thus be printed lithographically: printing ink is applied to the gelatine and is accepted in inverse proportion to the amount of moisture retained by the surface, the dry areas accepting most and printing darkest.

A collotype can be recognized by the rich depth of tone, and the fine reticulated grain of the gelatine which wrinkles as it dries.

The first commercial collotypes were produced in 1868 in Germany by Josef Albert and in 1869 in England by Ernest Edwards. Until the development of the half-tone screen it was the only photomechanical process, apart from hand photogravure, capable of reproducing tone. The making and printing of collotype plates is highly skilled and expensive work and can easily go wrong; not only are variations in humidity likely to upset the balance of moisture in the gelatine, but the surface is too delicate to produce more than about 2,000 impressions. For these reasons collotype has in the main been used for luxury publications and since the last war has been largely abandoned. This is a pity, for collotype is the most accurate and beautiful method of photomechanical reproduction yet invented.

100 Macrophotographic enlargement showing the grain of a collotype.

Processes of Colour Printing

The usual method of colour printing in all photomechanical processes depends on Newton's theory that all colour is composed of only the three primary colours, red, yellow and blue. A photographic negative separation of each colour is made using filters and transferred by one of the processes described above to a plate. The three plates are then successively printed to build up the coloured image. In modern printing a fourth plate of black is invariably added to strengthen the shadows. Effective four-colour printing was not developed before about 1920, because of the difficulty of producing sufficiently accurate photographic filters and the correct inks, and achieving the exact registration of the plates. Since the last World War most colour separation work has been taken over by newly-invented types of electronic scanner.

A more accurate but laborious method of colour printing abandons the three- or four- colour theory in favour of making specially chosen separations of colour on to as many plates as are

necessary. This is in effect the same procedure as that of the nineteenth-century chromolithographer, and requires great skill and care on the part of the printer. For this reason and because the number of plates adds to the printing time, this method is only used in exceptional circumstances.

101 Jean Michel Papillon *Flowers*, 1765. Woodcut (actual size). An example of a *cul-de-lampe* (tail-piece).

Print Catalogues

This section is intended to introduce the student to some of the standard catalogues of prints. It is not concerned with the numerous monographic catalogues of the works of individual or selected groups of printmakers, but rather with the general catalogues that cover entire schools and which are constantly referred to in the literature. Unfortunately very few of these catalogues are illustrated at all, and only one has illustrations of every item. The most comprehensive bibliography is the *Dictionary Catalog of the Prints Division of the New York Public Library*, Boston, 1975. This reproduces in five enormous volumes all the index cards to books about prints in the New York Public Library. Copies may be found in the Victoria and Albert Museum Library and the Print Room of the British Museum.

The fundamental catalogue of prints was written by Adam Bartsch in twenty-one volumes, published in Vienna from 1803 to 1821. This catalogues the work of only selected printmakers active almost entirely before 1700; the title, *Le Peintre-Graveur*, a term sometimes translated as 'painter-engraver', reflects Bartsch's interest in original as opposed to reproductive prints. Volumes 1 to 5 cover Dutch and Flemish engravers, 6 to 11 the German, and 12 to 21 the Italian. Bartsch's industry and thoroughness was such that his catalogue is only superseded for parts of the Dutch, Flemish and German schools, and remains fundamental for Italian prints. A project to publish a series of volumes of illustrations to Bartsch has recently got under way; some volumes have already been published and the remainder can be expected to follow.

Supplements to Bartsch were published by R. Weigel (1843) and J. Heller (1844). Far more important is the supplement of J. D. Passavant, *Le Peintre-Graveur*, 6 volumes, Leipzig, 1860–4. This is particularly concerned with material of the fifteenth and sixteenth centuries.

The only book to make any attempt at cataloguing every print produced over a long period was compiled by C. Le Blanc, *Manuel de l'Amateur d'Estampes 1550–1820*, 4 volumes, Paris, 1854–89. This is based on the collection of the Bibliothèque Nationale in Paris, and provides the only available lists of the works of many minor engravers, but is too summary and incomplete to be of much use.

Useful lists of works will be found under the individual artists' entries in two general dictionaries of artists. The earlier was G. K. Nagler, *Neues allgemeines Künstler-Lexicon*, 22 volumes, Munich, 1835–52. Nagler also published a supplement entitled *Die Monogrammisten*, 5 volumes, Munich, 1858–79, which is invaluable for identifying any print which only carries an artist's monogram. The second dictionary was by J. Meyer, *Allgemeines Künstler-Lexicon*, 3 volumes, Leipzig, 1872–85. This was intended to replace Nagler and contains excellent lists of engravers' works, but unfortunately

never got farther than BEZZUOLI. Later general dictionaries of artists, written at a time when prints had ceased to be much regarded, have in general made no attempt to supply any catalogues of prints.

The other catalogues are restricted to particular periods or schools.

Catalogues of Fifteenth-Century Prints
WOODCUTS AND METALCUTS. The standard work is by W. L. Schreiber, *Manuel de l'Amateur de la gravure sur bois et sur métal au XVᵉ siècle*, 5 volumes, Leipzig, 1891–1911. Volumes 4 and 5 contain a catalogue of blockbooks and incunabula with woodcut illustrations. Volumes 1 to 3 only, which list the single-sheet prints, were revised and reprinted as *Handbuch der Holz- und Metal-schnitte des XV Jahrhunderts*, 8 volumes, Leipzig, 1926–30. The catalogue is arranged according to the subject-matter of the print.
ENGRAVINGS. The standard work on Northern engravings is by Max Lehrs, *Geschichte und kritischer Katalog des deutschen, niederländischen und französischen Kupferstichs im XV Jahrhundert*, 9 volumes, Vienna, 1908–34. This catalogue is arranged by artist. For the Italian engravers it is complemented by A. M. Hind, *Early Italian Engravings*, 7 volumes, London, 1938–48; this is fully illustrated.

Catalogues of the Prints of Particular Schools after the Fifteenth Century
AMERICAN. D. M. Stauffer, *American Engravers upon Copper and Steel*, 2 volumes, New York, 1907, has a supplement published by Mantle Fielding, Philadelphia, 1917. The lithographs are described in two complementary catalogues, both by H. T. Peters: *Currier and Ives*, New York, 1929; *America on Stone*, New York 1931 (for non-Currier and Ives lithographs). The only substantial listing of (mainly) twentieth-century prints is the catalogue of *American Prints in the Library of Congress* by Karen F. Beall and others, Baltimore, 1970.
BRITISH. The only general catalogue is restricted to mezzotints: J. Chaloner Smith, *British Mezzotinto Portraits, from the introduction of the art to the early part of the present century*, 4 volumes, London, 1883. There are also two important museum catalogues: *Catalogue of Political and Personal Satires in the Department of Prints and Drawings in the British Museum*, volumes 1 to 4 (1320 to 1770) by F. G. Stephens, 1870–83; volumes 5 to 11 (1761 to 1832) by M. D. George, 1935–54. (A complete microfilm of all these satires is now available). *Catalogue of engraved British Portraits in the Department of Prints and Drawings in the British Museum*, 6 volumes, 1908–25, by F. O'Donoghue and H. M. Hake.

DUTCH AND FLEMISH. Five catalogues should be mentioned:
1. J. P. van der Kellen, *Le Peintre-Graveur Hollandais et Flamand*, Utrecht, 1866. This continuation of Bartsch covers the work of various seventeenth-century artists, but never went beyond the first volume.

2. E. Dutuit, *Manuel de l'Amateur d'Estampes*, volumes 4 to 6, Paris, 1881–5. This keeps to Bartsch's numbering, but revises his information about states. (Dutuit's first volume is about block-books and nielli; the second and third were never published).

3. A. von Wurzbach, *Niederländisches Künstler-Lexicon*, 3 volumes, Vienna, 1906–11. A general dictionary of Netherlandish artists which includes important lists of engravers' works.

4. F. W. H. Hollstein, *Dutch and Flemish Etchings, Engravings and Woodcuts c. 1450–1700*, Amsterdam, 1949 continuing. Twenty volumes are so far published from A-VAN RYSSEN. This catalogue is well illustrated.

5. T. Hippert and J. Linnig, *Le Peintre-Graveur Hollandais et Belge du dix-neuvième siècle*, 3 volumes, Brussels, 1874–9.

FRENCH. Bartsch did not include French prints, with the exception of the school of Fontainebleau. The basic catalogue is therefore A. P. F. Robert-Dumesnil, *Le Peintre-Graveur français*, 11 volumes, Paris, 1835–71. This work, completed after the author's death by G. Duplessis, includes the work of artists born in the seventeenth century. It is continued for the eighteenth century by P. de Baudicour, *Le Peintre-Graveur français continué*, 2 volumes, Paris, 1859–61. The work of the reproductive engravers finds a place in R. Portalis and H. Beraldi, *Les Graveurs du dix-huitième siècle*, 3 volumes, Paris, 1880–2. The only general catalogue for the nineteenth century is H. Beraldi, *Les Graveurs du dix-neuvième siècle*, 12 volumes plus supplement, Paris, 1885–92. The work of various important artists of the late nineteenth and early twentieth century is catalogued by L. Delteil, *Le Peintre-Graveur Illustré*, 31 volumes, Paris, 1902–26.

The Bibliothèque Nationale in Paris is in the process of publishing a vast inventory of its collection of French prints, the *Inventaire du Fonds Français*, of which the first volume was published in 1930. At present the sixteenth century is complete (2 vols), the seventeenth century is as far as LECLERC (7 vols), the eighteenth is at LE GRAND (13 vols) and the nineteenth at LYS (14 vols). The Bibliothèque Nationale has also published some important catalogues of its collections of French historical prints.

GERMAN. A standard work on early sixteenth-century woodcuts is Dodgson's British Museum catalogue (see p. 132). The work of

Bartsch was continued by A. Andresen, *Der deutsche Peintre-Graveur ... von dem letzten Drittel des 16 Jahrhunderts bis zum Schluss des 18 Jahrhunderts*, 5 volumes, Leipzig, 1864–78. This in turn was continued by A. Andresen, *Die deutschen Maler-Radierer des 19 Jahrhunderts*, 5 volumes, Leipzig, 1878. A new work is F. W. H. Hollstein, *German Engravings, Etchings and Woodcuts c. 1400–1700*, Amsterdam, 1954 continuing. Eighteen volumes are so far published from A – GRAF and KANDTPALTUNG – LORCH. Like the companion volumes on Dutch and Flemish prints, these are well illustrated.

ITALIAN. The only continuation of Bartsch is A. de Vesme, *Le Peintre-Graveur Italien*, Milan, 1906. This includes the most important etchers and engravers of the eighteenth century.

102 J. M. Moreau, the younger, and J. B. Simonet after P. A. Baudouin *Le Couché de la Mariée*, 1770. Etching (by Moreau) finished with the burin (by Simonet) (greatly reduced). A detail showing only the lower half and the lettering.

General Bibliography

The following list is highly selective and is restricted as far as possible to books written in English. Recent paperback reprints of many titles are available.

GENERAL

W. M. Ivins, Jr., *How Prints Look,* New York (Metropolitan Museum), 1943. (This, and the book by Brunner, are warmly recommended to those who wish to study techniques in greater detail.)
Prints and Books, informal papers, Cambridge (Mass.), 1927.
Prints and Visual Communications, Cambridge (Mass.), 1953. (The most brilliant and idiosyncratic book ever written about prints.)

Felix Brunner, *A Handbook of Graphic Reproduction Processes,* Teufen, 1962

A. Hyatt Mayor, *Prints and People, a social history of printed pictures,* New York (Metropolitan Museum), 1971

Paul Kristeller, *Kupferstich und Holzschnitt in vier Jahrhunderten,* 4th. ed., Berlin, 1922. (Still the best history of printmaking before 1800.)

Jean Laran, *L'Estampe,* Paris, 1959. (For French prints and bibliography.)

Richard Godfrey, *Printmaking in Britain: a general history from its beginnings to the present day,* Oxford, 1978

Riva Castleman, *Prints of the Twentieth Century, a history,* London, 1976

David Bland, *A History of Book Illustration,* 2nd. ed., London, 1969

Andrew Robison, *Paper in Prints,* Washington (National Gallery of Art), 1977

RELIEF PRINTS

Campbell Dodgson, *Catalogue of Early German and Flemish Woodcuts in the British Museum,* London, 1903 and 1911. (The best introduction to fifteenth- and early sixteenth-century woodcuts.)

A. M. Hind, *An Introduction to a History of Woodcut,* London, 1935. (A highly specialized work on fifteenth-century woodcuts.)

D. P. Bliss, *A History of Wood-Engraving,* London, 1928. (This is in fact a general history of relief prints.)

Max J. Friedländer, *Der Holzschnitt,* 4th ed., rev. by H. Möhle, Berlin, 1970

J. Jackson and W. A. Chatto, *A Treatise on Wood Engraving,* London, 1839. (2nd. ed., 1861)

INTAGLIO PRINTS

A. M. Hind, *A Short History of Engraving and Etching,* 3rd. ed., London, 1923

E. S. Lumsden, *The Art of Etching,* London, 1925

Anthony Gross, *Etching, Engraving and Intaglio Printing,* London, 1970

S. T. Prideaux, *Aquatint Engraving, a chapter in the history of book illustration,* London, 1909

A. Whitman, *The Masters of Mezzotint,* London, 1898

LITHOGRAPHY

Stanley Jones, *Lithography for Artists,* London, 1967

Michael Twyman, *Lithography 1800–1850, the techniques of drawing on stone in England and France and their application in works of topography,* London, 1970

Felix H. Man, *Artists' Lithographs, a world history,* London, 1970

SCREENPRINTING

Brian Elliott, *Silk-Screen Printing,* London, 1971

COLOUR PRINTING

R. M. Burch, *Colour Printing and Colour Printers,* London, 1910

PHOTOGRAPHIC PROCESSES

Harold Curwen, *Processes of Graphic Reproduction in Printing,* 4th. ed., London, 1966

John Lewis and Edwin Smith, *The graphic reproduction and photography of works of art,* London, 1969

Charles Newton, *Photography in Printmaking,* London (Victoria and Albert Museum), 1979

Geoffrey Wakeman, *Victorian Book Illustration, the technical revolution,* Newton Abbot, 1973. (Invaluable for the odd nineteenth-century processes.)

A SELECTION OF OTHER LITERATURE

William Faithorne, *The Art of Graving and Etching,* London, 1662. (The earliest book on prints in English; the text is adapted from Bosse's French text of 1645.)

Robert Dossie, *The Handmaid to the Arts,* London, 1758. (The section on prints contains a wealth of information.)

William Gilpin, *An Essay upon Prints,* London, 1768

Joseph Maberly, *The Print Collector,* London, 1844

H. C. Levis, *A Descriptive Bibliography of the most important books in the English Language relating to the Art and History of Engraving and the collecting of prints,* London, 1912

Walter Sickert, *A Free House!* London, 1947. (An anthology of Sickert's essays; the section entitled 'Down Etching-Needle Street' includes his most amusing and provocative views about prints.)

Abbreviations and Lettering

In this and the following sections translations of technical terms into French and German are only given in the more important cases. The fullest such dictionary, which covers German, French, English, Italian and Dutch, is to be found in Walter Koschatzky, *Die Kunst der Graphik*, Salzburg, 1972. The best glossary available is H. W. Singer, *Die Fachausdrücke der Graphik*, Leipzig, 1933.

Numerous abbreviations and other terms have been used on the lettering (qv) of prints and these have to be understood in order to find out the roles of the various names in the production of the print. The following section is intended to explain the more important and obscurer terms. They have been arranged in four groups; the normal abbreviations are in brackets.

PRINTMAKER AND RELATED CRAFTSMEN (usually placed beneath lower right-hand corner of image)

Aquaforti (aqua.) 'Etched'; used of the etcher.

Caelavit (cae.) 'Engraved'.

Direxit (direx.) 'Directed' (the engraving); found on some eighteenth- and nineteenth-century prints, especially in France, where a master was directing the operation of a workshop.

Fecit or *faciebat (f.* or *fac.)* 'Made'; used by engraver or etcher.

Impressit (imp.) 'Printed'; only found from the eighteenth century. In the late nineteenth and early twentieth centuries the printer sometimes signed his name in manuscript.

Incidit or *incidebat (inc.)* 'Engraved'; never used on an etching.

Lithog. This is an ambiguous term; it can be used either by the man who drew the image on the stone, or by the lithographic printer.

Photosculpsit (ph. sc.) Sometimes used by the craftsman who prepared a hand photogravure plate.

Scripsit (scrip.) 'Wrote'; used by the specialist writing engraver, and found most commonly in the eighteenth century.

Sculpsit or *sculpebat (sc.* or *sculp.)* 'Engraved'; the most usual term used by the engraver.
Occasionally a woodcutter will place his name beside a miniature knife.

PAINTER AND DRAUGHTSMAN (usually placed beneath lower left-hand corner of image)

Ex archetypis 'From the original' painting, drawing, etc.

Composuit (comp.) 'Designed'; used of originals of many types. It is also occasionally used by the author of the verses found under mannerist prints; an alternative in these cases is *lusit*.

Delineavit (del. or *delin.)* 'Drew'; used when the engraver was working from a drawing, often a copy of a painting, etc., made by an intermediate artist especially for the engraver.

Descripsit 'Drew'; the same as the above, but rarer.

Designavit (desig.) 'Designed' or 'drew'.

Effigiavit (effig.) 'Drew'; equivalent to *delineavit*.

Figuravit (fig.) 'Drew'; usually this has the same implication as the above.

Invenit (inv.) 'Designed'; the most common term for original compositions of all sorts.

Pinxit or *pingebat (pinx,* or *ping.)* 'Painted'.

PUBLISHER

Appresso 'At the house of' (Italian).

Apud (The Latin for the above).

Chez (The French version; often in form *se vend chez*).

Divulgavit (divulg.) 'Published'.

Excudit (ex. or *excud.)* 'Published'; the most common term.

Ex officina 'From the workshop'.

Ex Typis 'From the printing house'; often used in Italy.

Formis 'At the press'; where the printer is also the publisher.

Gedruckt zu 'Printing by'; normally found on German woodcuts.

Per 'Through'.

Sumptibus 'At the expense of'; used of a patron or a publisher.

COPYRIGHTS *('privileges')*

1. Great Britain. *Published According to Act of Parliament* (From 1735).

2. France. *Cum Privilegio Regis (CPR)* or *Avec Privilège du Roi (APDR)* (Until 1793); *Déposé à la Direction* (From 1795–9); *Déposé à la Bibliothèque Impériale* (1804–14); *Déposé à la Bibliothèque Royale* or *Nationale* (1815 onwards).

3. Germany. *Cum Privilegio Sacrae Caesaris Maiestatis (CPSCM)* (Used in the area within the jurisdiction of the Holy Roman Emperors).

4. Italy. (a) *Superiorum permissu* or *Con licenza de' superiori* (Used by the ecclesiastical censorship in Rome; although privileges were granted, this in itself does not imply one).
(b) *Cum Privilegio Excellentissimi Senatus (CPES)*. (A Venetian privilege).

5. America. *Entered according to Act of Congress*.

MANUSCRIPT ANNOTATIONS

Artist's proof (AP) A few 'artist's proofs' are usually printed in addition to the main edition of a print. See p. 144.

Bon à tirer 'Good to print'; the artist's indication to the printer that that particular impression should act as standard for a whole edition. In English the term 'Good to pull' is sometimes used.

Épreuve d'artiste 'Artist's proof'.

Épreuve d'essai 'Trial proof'.

Épreuve d'état 'State-proof'; used when working is not yet completed.

Épreuve de passe Sometimes found written on an extra impression printed beyond the stated number of the edition.

Handdruck 'Printed by hand' (German); implies that the impression was printed by the artist himself.

Hors Commerce (HC) 'Not for sale'; usually of an extra impression beyond the stated limits of an edition.

Probedruck 'Trial proof' (German).

Glossary and Index

Address A term used generally of any lettering on a print which gives the name of the publisher (qv).

Altered Plates A phenomenon most often found among portrait prints. A publisher, to save expense, would simply burnish out the face and lettering of a disused plate and substitute new features. One famous plate began as Cromwell, was turned into Louis XIV, was turned back into Cromwell and then became Charles I before finally returning to Cromwell again. See G. S. Layard, *Engraved British Portraits from Altered Plates*, London, 1927.

Anastatic Printing This is in essence a method of transfer lithography, and was occasionally used between about 1840 and 1900 to print from a manuscript or printed book. The page was soaked to loosen the grease in the ink and the image was transferred to a zinc plate, which was then printed lithographically.

Aquatint (French *manière de lavis*) An intaglio method in which tone is created by etching around grains of resin. See pp 91ff.

Artists' Prints A term applied to those prints which are (in some sense) original graphic creations by an artist. It is used interchangeably with 'original print' in its second meaning as defined on p. 10.

Autography Although sometimes found in English, this is not really an English term. It is a translation of the French 'autographie' which means transfer lithography (qv).

Autotype A process occasionally used in Victorian book illustration. Autotypes are in fact not prints, but a variety of photograph.

Banknotes Like postage stamps, banknotes are not usually considered as being within the province of the connoisseur of prints. They do however often exhibit the most sophisticated of mechanical engraving techniques. See A. D. Mackenzie, *The Bank of England Note*, Cambridge, 1953.

Baxter George Baxter in 1835 patented a printing technique under his own name. It involved overprinting an intaglio key-plate with numerous wood or metal blocks inked in oil colours. Although after 1849 he sold licenses to others (of whom the best were Le Blond, Kronheim and Dickes), the process was abandoned after 1865. See p. 117.

Bevelling See sv. plate-mark.

Blind-stamping. See sv. embossing.

Blind-stamps Print publishers and a few printmakers have sometimes since the nineteenth century used individual blind-stamps on their products. Many of these are listed by Lugt (cf. sv. collectors' marks). American publishers have taken to calling these stamps 'chops' (a term borrowed from its proper context with Japanese prints).

Blockbooks The name given to a group of books produced in the fifteenth century in the Netherlands and Germany. Unlike normal books, both text and image were printed from wood blocks. The labour of cutting letters on a block ensured that the process was only used for popular best-sellers such as the *Biblia Pauperum* (Paupers' Bible) and the *Ars Moriendi* (Art of Dying). In the nineteenth century there was great interest in blockbooks as they were thought to pre-date the invention of movable type in about 1453, but it is now almost certain that they are later. They remain, however, most interesting, and some designs have been attributed to major Netherlandish artists.

Book-plates The custom of producing a personal or official book-plate can be traced back to the 1480s. Millions have been designed, both woodcut and engraved; the majority simply bear coats of arms. There is a very large collection in the British Museum.

Broadsheets These have often carried woodcut illustrations, which at some periods (especially in Germany in the sixteenth and seventeenth centuries) have formed an important part of the production of woodcuts.

Burin (German *Grabstichel*) The basic tool of the engraver. See p. 22.

Burr The ridge of copper raised by a drypoint needle, which prints as a rich smudge. See p. 74.

Cancelled plates When the printing of a limited edition (qv) of prints has been completed, it is usual to deface the plates or stones to ensure that there is no possibility of their being reprinted. A few 'cancellation' impressions are often run off to prove the cancellation and reassure speculators. It has happened that impressions even from cancelled plates have been marketed (eg. with Degas), or that the cancellation marks have been carefully removed and impressions marketed as if they were pre-cancellation (eg. with Manet and Whistler).

Chalcography There are three national chalcographies in the world, all of which maintain large stocks of engraved plates from which impressions are printed as ordered by the public. The first was founded by Clement XII in Rome in 1738 with the stock of the Rossi family of publishers; its most important holdings are almost all the plates of Piranesi, purchased from Firmin-Didot in Paris in 1839. The Madrid chalcography followed in 1789, and owns most of Goya's plates. The one in Paris was founded in 1797, but used as its basis the stock of plates manufactured for the *Cabinet du Roi* since 1667. The Italian and French establishments have habitually identified their productions with blind-stamps.

Chalk-manner Another term for crayon-manner (qv).

Chapbooks Small and cheap books meant for the popular market. They are often of interest to print historians for their crude woodcut illustrations.

Chemitype An unusual process, used between 1846 and about 1890. It was a method of transforming an intaglio plate into a relief block. The etched lines on a zinc plate were filled with a molten metal that was able to resist the action of acid; the zinc was then etched down to leave the other metal standing in relief.

Chiaroscuro woodcut (French *camaieu* or *clair-obscur*; German *Helldunkelschnitt* or *clair-obscur*) A colour woodcut used to suggest the effect of a monochrome tonal drawing. See p. 116.

Chromolithograph A colour lithograph; often reserved for application in a derogatory sense to

103 Netherlandish *Biblia Pauperum* Blockbook *The Crucifixion, c.* 1465.
Woodcut (reduced). The scene is flanked by two Old Testament parallels,
Abraham's sacrifice and the raising of the serpent. At the top and bottom are
quotations from four prophets.

high Victorian productions. See p. 121.

Cliché-Verre A process which has as much in common with photography as with printmaking, but which is usually regarded as a printmaking technique because it was used by Corot, Millet, Rousseau and Daubigny (but few others) in the period from 1853 to 1874. The artist draws with a point on a glass plate coated with an opaque ground, from which positive photographic prints are printed on sensitized paper as from an ordinary photographic negative. The process has been taken up again in America in the 1970s.

Collectors' Marks Many collectors have stamped their prints with a personal mark of possession. Such marks are listed by F. Lugt, *Les Marques de Collections*, Amsterdam, 1921 (*Supplément*, The Hague, 1956).

Collotype (French *phototypie*; German *Lichtdruck*) A photomechanical process. See p. 126.

Colour printing See pp. 114ff.

Compound-plate printing A process used from 1820 for printing banknotes and suchlike; an engraved steel plate was divided into pieces which were separately inked before being rejoined and printed. A variety of this method had already been used by Fust and Schoeffer in the coloured initial letters of the Mainz Psalter of 1457, and it was later adapted to woodcut by Edvard Munch. See p. 117.

Copper plate The usual kind of plate used in the intaglio printmaking processes; for this reason their products are sometimes referred to as copper-plate prints.

Copy This word is dangerously ambiguous. In the sense in which we talk of a *copy* of a book, the word *impression* should be used of a print. The term *copy* in prints should be strictly reserved for a re-drawing of an original done by another hand. If done by the original designer, such a copy is referred to as a *replica*. Most copies are straight forward piracies, made in centres outside the range of any possible enforcement of copyright. The most notorious of these was perhaps Augsburg, where huge numbers of seventeenth- and eighteenth-century French ornamental prints were pirated. Other types of copy are more complicated. There are astonishingly exact contemporary copies of many prints by Marcantonio and Lucas van Leyden; it is sometimes unclear which is the original and which the copy, and frequently uncertain whether the copy is a piracy or an autograph or studio replica. Further problems occur with sixteenth-century German woodcut portraits and Italian topographical prints. The demand for these was so large that copies of copies were turned out in many variants, and it is very difficult to reconstruct the complete sequence.

Copyright Copyrights (or 'privileges') for a limited number of years have been given to books and prints by many governments since the fifteenth century. Artists and publishers have signalled such protection to potential pirates by adding copyright lines to their blocks and plates. A partial list of these is given in the entry on abbreviations.

Counterproof A counterproof is an offset from a print (or a drawing) on to another sheet of paper. It is made by running the print, before the ink has dried, through a press against another sheet. The resulting image is in reverse to the print, but in the same direction as the plate, and is often used by the artist in making corrections (see **106**). Occasionally with ornamental prints only half of a design is engraved and printed, and the other half completed by folding the sheet in halves and making a matching counterproof. Another use of counterproofs is sometimes found to reverse a reproductive print to the same direction as the original painting; some prints were actually published in this form.

Crayon-manner An intaglio method which uses tools to make a facsimile of a crayon drawing. See p. 82.

Culs de lampe The French term used for the small decorative tail-pieces printed at the end of each chapter in an illustrated book. They are most often found in eighteenth-century books and are usually wood-engraved. The corresponding designs at the beginning of the chapter are called head-pieces. See **101**.

Dotted prints (French *manière criblée*; German *Schrotblatt*) A class of fifteenth-century metalcut with punched decoration. See p. 28.

Drypoint (French *pointe sèche*; German *Kaltnadel*) The intaglio method in which a plate is directly scored by a needle. See pp. 74ff.

Échoppe The tool by which Callot made etchings look like engravings. See p. 64.

Editions In the early centuries of printmaking plates were kept in the possession of the artist or publisher who ran off more impressions as needed until the plate wore out. In this period it is only possible to talk of an edition of a print if it was published in a book or if at some stage it changed publisher; in the latter case editions can only be distinguished by a change of address in the lettering or (occasionally) by differences in paper. In the eighteenth century in France and Britain it became customary to issue prints in various states, for example in the etched state (see p. 53) or before and after letters. These can reasonably be called different editions. The word's current significance only arose in the later nineteenth century as a result of the practice of artificially limiting the supply of a print. A print would be published in an *edition* of (say) fifty, with a guarantee that the plate would be cancelled (qv) afterwards. This ludicrous trick has now been adopted almost universally for marketing purposes, and its success has only been possible because of the investor (or, rather, speculator) mentality of buyers and the premium misguidedly placed on rarity (qv). One consequence has been that publishers trying to get round their own limits have multiplied so-called printer's and artist's 'proofs' (see sv. proof).

Electrotype An electrotype is an exact duplicate of a block or plate which has been produced by electrolysis. The process was invented in 1839, and soon made stereotyping (qv) obsolete. In the later nineteenth century wood-engravings made for book illustration, etc., were almost invariably printed from electrotypes of the blocks.

Embossing A printmaking method in which a design is impressed into paper without the use of any ink. Embossing is occasionally found throughout the centuries, and was often used in Victorian Christmas cards and suchlike. J. B. Jackson in the eighteenth century and later Munch and the German Expressionists used it to give relief to their woodcuts and it has been employed in pure form in some prints of the 1960s.

Engraving (the process) (French *gravure en taille douce*; German

104

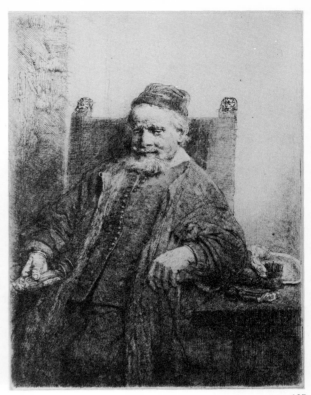

105

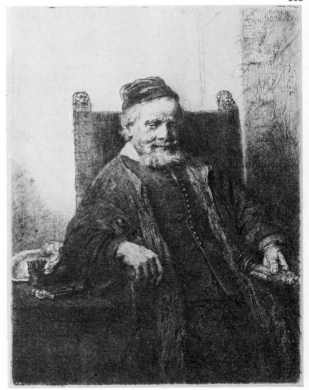

106

104–106 Rembrandt *Jan Lutma*, 1656. Etching and drypoint (greatly reduced). **104** is a normal impression; **105** is a maculature; **106** is a counterproof. Jan Lutma was the inventor of the method of punched engraving (see p. 80).

Grabstichelarbeit) The method of working metal with a burin. Although most frequently used for making plates for printing purposes, engraving has also always been employed as a method of decorating metal (especially silver). Hogarth was first apprenticed to an heraldic silver engraver, and many minor engravers must have spent as much of their time on these objects as on plates for printing. The engraving of gems and glass was a different trade, with its own special skills.

Engraving (the object) (French *gravure*; German *Kupferstich*) Properly only used of a print taken from an engraved plate. The term is however often used loosely to cover all intaglio prints. See pp. 35ff and the note on p. 38.

Etching (French *eau-forte*; German *Ätzung* (process) and *Radierung* (object)) The second most important intaglio method, in which the lines are bitten by acid. See pp. 56ff.

Etching à la plume A variety of sugar-aquatint which produces the effect of a pen line. See p. 93.

Experimental processes A large number of short-lived processes were tried in the nineteenth century. Most of these are described in Wakeman's book (see bibliography); others can be found in E. M. Harris' articles in the *Journal of the Printing Historical Society*, nos. 4 and 5 for 1968 and 1969.

Fakes and Falsifications The earliest 'fakes' were simple piracies; the most famous are Marcantonio's copies from Dürer (see p. 44). True fakes only appear with the rise of the collector. These were sometimes very exact copies masquerading as originals (especially of Dürer and Rembrandt), and sometimes pastiches in a master's style (though the pastiches by an engraver such as Goltzius were made to show off his skill, not to deceive). Occasionally genuine blocks or plates by minor masters had the signature of a more important artist added. The invention of photomechanical reproduction processes produced a new type of fake: the reproduction printed on a sheet of old paper or otherwise doctored to look like an original. Falsifications are, however, more dangerous and deceptive than outright fakes. Damaged originals can be so thoroughly and expertly repaired as to

go far beyond any legitimate restoration; thus a cut print will have areas made up in ink and margins added. More often an impression will be 'improved'. Drypoints are said to 'have their faces lifted' by adding 'burr' with ink wash, and a worn print will have the lines strengthened with the pen. Another type of falsification tries to turn a later state of a print into a desirable early one. Sometimes letters or areas of working are simply scratched off the surface of a print, but more often the deception takes place during the printing itself. Areas of the design or lettering are left uninked or are covered with slips of paper so that they fail to print. Such 'masked' impressions can be identified by the impress of the uninked letters or the edge of the slip of paper. A final type of falsification is mentioned in the entry on cancelled plates. See Otto Kurz, *Fakes*, London, 1948, pp. 106-14.

Flock prints A curious and very rare class of fifteenth-century woodcut. The block was 'inked' with glue and printed onto paper, on which fluff of minced wool (flock) was then dusted. The process was later used for wallpaper.

Foul-biting This occurs whenever an etching ground collapses and allows the acid to attack the plate indiscriminately. See p. 57.

Foxing A name used for the patches of discolouration which mar the appearance of the paper of many books and prints. It seems to be a fungoid growth which thrives in damp conditions, and which, if left untreated, destroys the structure of the paper. Later eighteenth- and nineteenth-century papers are particularly vulnerable, while earlier ones are relatively immune, presumably because they were made from better quality materials.

Gaufrage A French term for embossing (qv), often used by writers on Japanese prints.

Gillotage A process, now obsolete, invented in 1850 by Firmin Gillot, which turned a lithographic plate into a relief plate. A lithographic drawing was made on or transferred to zinc and dusted with resin which acted as a resist. The plate was then etched to make a relief block. Many of Daumier's lithographic plates were treated in this way before their publication in newspapers. The technique of producing a *gillotage* is

very similar to that of a line-block; the main difference is that the design is not transferred photographically.

Glass prints In the late seventeenth and early eighteenth centuries mezzotints were often glued face down on to glass, and rubbed from behind to remove all the paper. The film of ink was then hand coloured and the glass framed. Such decorative items are often called glass prints, but they are of course completely distinct from the *cliché-verre* (qv).

Glyphography A process invented by Edward Palmer and patented in 1842. A drawing was made through a white composition spread over a metal plate. When finished, the surface of the plate was raised by adding material wherever the composition remained. The block was then electrotyped and the electrotype used as a mould from which to cast a relief printing block. An earlier variety of this process called *gypsography*, in which the drawing was made through a block of plaster mounted on a metal base, was patented in 1837.

Half-tone A method of breaking up a continuous-tone image into dots by photographing it through a cross-lined screen. It is a fundamental part of many of the photomechanical printing methods. See p. 123.

Hectography An early method of duplicating invented around 1880, but now obsolete. A text or design is written in a special ink on a sheet of paper, and transferred on to a jelly compounded of glycerine and gelatine by being placed face down on top of it. Wet sheets of paper are then rolled over the surface of the jelly, and the design is transferred to them. Hectography was mostly used in offices before the invention of photocopying; the Russian Futurists were almost the only artists to make use of it in some of their illustrated books. Its successor, the photocopying machine, has also recently been used for printmaking by some American artists.

Heliogravure A French term, sometimes adopted into English, for what is here called hand photogravure. See p. 124.

Impression To be distinguished from a copy (qv).

Ink Printing ink is an oil-based fluid, quite distinct from the water-based liquid used for writing. It was

107 Anonymous, *Autumn and Winter*, English, 1805. Mezzotint pasted to glass and coloured by hand (a 'glass print') (greatly reduced).

apparently invented, or at least developed, by Gutenberg, and was as essential to his success as his invention of the printing press and movable type. The ink is made by grinding lamp black very fine and mixing it with oil; less oil is used in a relief or typographic ink than in intaglio ink in order to make it more viscous so that it will not run into the hollows. Lithographic ink has to contain grease to resist the water – the fundamental principle of lithography. In screenprinting the ink can be almost anything that will pass through the mesh and adhere to paper; thus many quite different fluids are suitable, which is one reason why screenprints can look so different from other sorts of print. See Colin Bloy, *A History of Printing Ink*, London, 1967.

Intaglio The method of printing in which the ink is pulled out of grooves made in a plate. See p. 30.

Lavis A term adopted here for washing a plate with acid. See p. 93. It was used by Tomás Harris in his catalogue of Goya's prints published in 1964. The French term *manière de lavis* is used more widely to refer to any method of achieving the effect of a wash drawing; thus it includes aquatint as well.

Leech The English caricaturist John Leech (1817–64) used a bizarre process to make some paintings which were exhibited in 1862. An impression of one of his wood-engravings for *Punch* was printed on to a piece of india-rubber and then enlarged eightfold by stretching the rubber. The design was then transferred to a lithographic stone from which impressions were printed on canvas. The artist finally coloured these with oil paints.

Lettering A term used to refer to any printed letters on a print; manuscript

annotations can be referred to as 'inscriptions'. The lettering on a print was usually entrusted to a specialist writing engraver. His skill was recognized in the name of one type of script – 'copperplate'. Very occasionally the writing engraver's name was added to the lettering. In the elaboration of states and proofs (qqv) which became a feature of print publishing in the later eighteenth and nineteenth centuries, lettering played an important role. Prints are sometimes found with titles in two or more languages. This was done by publishers in order to increase their foreign sales.

Letterpress The term used for all book printing done from a relief press. Although it was the only method of book printing until the nineteenth century, it has been made commercially obsolete in the last two

LE COUCHÉ

A très Haut

Armand - Charle

Comte d'hautefort, Marquis de Villacerf,

& Meſtre de Camp du Regiment

chés Moreau le Jeune rue de la Harpe vis à vis M.le Bas.

la Gouache par P.A. Baudouin

DE LA MARIÉE

et très Puiſſant Seigneur

Emmanuel d'hautefort,

Grand d'Espagne de la Premiere Claſſe

de Cavalerie Royal Etranger.

Par ses très humbles et très Obéissants Ser

Baudouin et Moreau le J.ne

Gravé à l'Eau f.te par J.M. Moreau et terminé par J.B.

A.P.D.R.

108 Detail of **102**, showing a fine specimen of eighteenth-century engraved lettering. The vignette in the centre is etched.

decades by developments in photo-typesetting and offset lithography.

Lift-ground etching Another term for sugar aquatint. See p. 93.

Line-block A photomechanical process. See p. 122.

Line-engraving A term sometimes used to avoid the possible ambiguity of 'engraving'. See p. 38.

Lino-cut An abbreviation for linoleum cut; the same process as woodcut except that linoleum is used instead of a block of wood. See p. 21.

Lithography (French *lithographie*; German *Steindruck* (process) and *Lithographie* (object)) A method of printing based on the fact that grease repels water. See pp. 101ff.

Lithotint A name coined for wash lithography. See p. 101.

Maculature After an impression has been printed from a block or plate, there are usually traces of ink left on it; these can be removed by printing the plate again on a clean sheet of paper. Such a ghostly impression is called a maculature (see **105**).

Manière criblée See sv. dotted prints.

Maps Before this century maps were always produced by the standard printmaking techniques, and many print publishers were also map publishers. See R. V. Tooley, *Maps and Map-Makers*, 4th. ed., London, 1970.

Margins Any area outside the plate-mark (qv) of an intaglio print or outside the drawn border of other classes of print is the margin. Prints were almost invariably trimmed down to their borders or plate-marks by owners before the eighteenth century. A print trimmed just outside the plate-mark is often described as having *thread margins*. In the nineteenth

century collectors began to place a quite irrational premium on margins; as a protest against this, Whistler, from about 1880, trimmed all his prints himself, leaving only a tab for his butterfly monogram. A distinct category is formed by some nineteenth-century book illustrations, which were given huge margins so that they could be cut in the binding inside the unsightly plate-mark.

Masked impressions See sv. falsifications.

Mattoir A tool with a rounded spiked head. See **69**, and p. 80.

Medal engraving A method of producing an amazingly lifelike two-dimensional facsimile of a coin or medal, using a tracing machine invented by Achille Collas in 1831.

Metalcut A relief printing method using a metal plate rather than a wooden block. See pp. 25ff.

Mezzotint (French *manière noire*; German *Schabkunst*) A process which works from dark to light by scraping down a roughened metal plate. See pp. 85ff.

Mixed method The term used in despair to describe those nineteenth-century intaglio prints produced from a mixture of many intaglio methods. See p. 89.

Monograms Many printmakers have signed their work with a monogram; the invaluable dictionary of these marks by Nagler is listed on p. 128.

Monotype An unworked metal plate can be painted with ink by an artist and printed on to paper; the ink will usually allow one strong and one weak impression. Because it involves printing, a monotype is traditionally regarded as a print, but since it cannot be multiplied it stands nearer to a drawing. The process was

invented by G. B. Castiglione in the 1640s; it was revived in the nineteenth century, notably by Degas and Gauguin, and has continued to appeal to artists for the remarkable effects that can be obtained.

Multiples One product of the print revolution of the 1960s was the multiple, a three-dimensional object published in a limited edition in the same way as pieces of cast sculpture.

Music printing It is worth pointing out that most music was printed from engraved plates between about 1700 and 1870, on account of the difficulty of typesetting notes on staves. See A. Hyatt King, *Four Hundred Years of Music Printing*, 2nd. ed., London (The British Museum), 1968.

Nature printing One of the most ingenious of Victorian inventions; some vegetable object (usually a plant or a leaf) was impressed under considerable pressure into a soft lead plate. This was then stereotyped or electrotyped, and the plate printed in intaglio to produce an astoundingly accurate image of the original. The process was developed by Auer in Vienna in 1852, patented in England by Henry Bradbury in 1853 and much used until the 1890s when developments in photomechanical methods made it uneconomic. It had a sort of predecessor in the eighteenth century when flat objects (especially textiles and leaves) were themselves inked and handprinted onto paper.

Nielli A niello is a piece of engraved metalwork (usually gold or silver), the furrows of which have been filled with a black metallic amalgam (Latin *nigellum*, whence the Italian *niello*). This method of decorating metal has been used continuously since antiquity, but was especially popular in Florence and Bologna in the years

109 John Bate *William Cheselden*,
c. 1885. Detail of a medal engraving
after a medal by William Wyon
(enlarged).

110 *below* Edgar Degas *Reclining nude, c.* 1883/5. Monotype
(greatly reduced).

111 Alois Auer *A small plant*, 1850s. Nature printing (reduced).

between about 1450 and 1520. It is of interest to the print historian because these metal plates, before being filled with niello, were sometimes printed onto paper to preserve a record of the design (a niello print). For a long time following Vasari these were thought to explain the beginning of intaglio printing in Italy, but the theory is now abandoned. A niello print is distinguishable from a normal engraving by its very small size and minute manner of working. They were presumably originally printed to guide the silversmith in his work or to preserve a record of a design, but so many prints survive that it is certain that plates were also made in this style for printing.

Numbering A number such as 34/75 on a print means that it is the thirty-fourth in a limited edition of seventy-five. The limited edition is not found before about 1880, and developed at the same time as artists began to sign their prints; numbering of individual impressions followed at the beginning of this century. A number such as 1/75 on a print does *not* imply that it was the first to be printed; the prints are usually assigned numbers as they come to hand in random order. Nor does it imply that there are only 75 impressions in existence; there will almost certainly be numerous additional artist's and other proofs (qv).

Offset An offset from wet ink on to another sheet of paper is sometimes seen; in the case of a counterproof (qv) such offsetting is deliberate.

Offset lithography A sophisticated development of lithographic printing often referred to simply as 'offset'. See p. 102.

Oleograph A nineteenth-century process whereby an ordinary colour lithograph was varnished and impressed with a canvas grain before publication in order to make it look like an oil painting. It has many modern successors; in one style an ordinary four-colour process reproduction is coated with a thick varnish applied in such a way that it has the effect of the impasto of paint.

Optical views Sometimes known as perspective views. A class of eighteenth-century engraving, usually hand-coloured and of a topographical subject, which can be distinguished by having its title written in mirror-writing. They were intended to be viewed through a special device, known alternatively as an optical diagonal machine or a 'zograscope'. This produces a reversed and magnified vertical image with the details in the picture apparently situated at a considerable distance from the observer as they would be if seen directly. See J. A. Chaldecott, *Annals of Science,* ix, 1953, pp. 315–22.

Original print The various meanings of this term are discussed on pp. 10–11.

Ornamental prints A large class of print which served an essential purpose from the mid-fifteenth to the nineteenth century. They were intended to suggest patterns of decorative ornament to craftsmen in all fields of the applied arts, and were usually published in small sets. Often very pretty in themselves, they are of vital importance to a history of ornament. The national collection is appropriately in the Victoria and Albert Museum. The standard catalogues are D. Guilmard, *Les Maîtres Ornemanistes*, Paris, 1880–1, and the *Katalog der Ornamentstichsammlung der Staatlichen Kunstbibliothek Berlin*, Berlin, 1939.

Pantograph A machine by means of which an accurate enlargement or reduction of a print or drawing can be made.

Paper The traditional way of making paper is to beat rags into a liquid pulp. Into this the papermaker scoops a tray of crossed wires on to which he settles a thin layer of fibres. This is then turned out and pressed and dried between felt blankets (from which the imprint of the hairs can often be seen on early paper). What we have at this point is in effect blotting-paper; to turn it into paper for writing or printing, it has to be sized with gelatine or glue. There are two main classes of paper. *Laid paper* (French *papier vergé*; German *Büttenpapier*) shows the pattern of the vertical 'wire-marks' and the horizontal connecting 'chain-lines' of the wires in the papermaker's tray. *Wove paper* (French *vélin*; German *Velinpapier*) is made from a tray with the wire mesh so tightly woven as to leave no marks visible; it was developed in 1755 in order to provide a smoother surface, but did not come into common use until about 1790. Both laid and wove papers can be given a watermark (qv) by incorporating a wire pattern in the mould. From about 1800 wood began to replace rags as the raw material of paper with disastrous results, for the chemical processes used in manufacture often caused it to turn brittle and discoloured. Although most European prints have been printed on to paper of these types, other surfaces have been used. These include vellum, silk and linen; the most commonly used

112 Anonymous, *Saints Leonard, Catherine and Antony of Padua*, Italian, *c.* 1475. Engraved silver plaque, the lines being filled with niello (enlarged).

papers of foreign manufacture are Japanese (of mulberry fibres) and Chinese (a very thin paper usually laid down in printing onto a backing of another sort of paper, and known incorrectly in Britain as India laid). Some familiarity with paper is essential for the print historian; European papers can usually be approximately dated from their appearance and feel, and a restrike or facsimile can often be detected in this way. See Dard Hunter, *Papermaking*, New York, 1947.

Paste prints A rare class of fifteenth-century woodcut. A layer of paste was spread evenly over a sheet of paper, and impressed with a pattern from a cut woodblock. About 150 examples are known.

Pastel-manner A method of colour printing using multiple plates engraved in the crayon-manner. See p. 119.

Perspective views See sv. optical views.

Photography Although photographs are collected by many European and American print departments, they can scarcely be called prints in the conventional sense. This is a purely semantic point, and is not intended to belittle the status of photography in any way. It is however intended to justify its exclusion from this book.

Photogravure A photomechanical process. See pp. 123ff.

Photomechanical processes Any process by which a printing surface is produced by a method based on photographic technologies rather than human skill.

Planographic A surface printing method. The word was originally coined to go with relief and intaglio in order to distinguish the third method of printing constituted by lithography. In theory screenprinting is also a planographic process, but this term is rarely if ever applied to it.

Plate-mark The line of indentation in the paper where it has been pressed around the edges of an intaglio plate. See p. 30. From the mid-nineteenth century the edges of plates were often given a wide bevel (i.e. smoothed down at a 45° angle). Occasionally prints, although printed in relief or lithographically, have been impressed with a meaningless plate-mark from a blank metal sheet. This is usually done with the intention of passing off a photomechanical reproduction as an intaglio print.

Plate tone A new copper plate will often have faint scratches and marks on its surface which will pick up ink in the wiping; this is called plate tone. The scratches wear down very quickly, and so plate tone is a sign of

a very early impression. It is to be distinguished from surface tone (qv).

Playing cards Documents show that many of the earliest European woodcuts were playing cards, although few of them survive. Many fine fifteenth-century engravings are also cards, but after the sixteenth century their design tends to become standardized and the quality drops. See C. P. Hargrave, *A History of Playing Cards*, 1930.

Pochoir The French for a stencil. During this century many School of Paris prints have been coloured through carefully cut stencils, and the term pochoir is often applied to these.

Polyautographs The name used by the publisher for the earliest lithographs made in England. See p. 105.

Polygraphs A rare type of print of very large size manufactured in England in the late eighteenth century first by Francis Eginton and later by Joseph Booth as imitation oil paintings; it is still unclear how they were made. See E. Robinson and K. R. Thompson, 'Matthew Boulton's Mechanical Paintings', *Burlington Magazine*, 1970, pp. 497–507.

Popular prints Ever since the fifteenth century, there has been a flourishing market in popular prints largely independent of the market for fine prints which has been described in the historical sections of this book. Being intended for a popular and unsophisticated market, they had to be cheap and thus were usually woodcuts; they take the form of chap-

113 Peregrino *Three dancing women*, *c*. 1500. Print from a plate engraved in the niello manner, but intended for printing (actual size).

books, broadsheets, ballads and so on. Very few survive from earlier than the nineteenth century. They have for a long time been studied in France; a work on British popular prints will appear in late 1980 (T. Gretton, *Murders and Moralities*, BM Publications).

Postage stamps In the early years after the introduction of prepaid postage stamps in 1840 all plates had to be hand-engraved, and in some countries they are still made this way. Although, like banknotes, rarely thought of as part of the history of engraving, these designs often exhibit extraordinary skill. The name of the engraver can sometimes be found in the bottom right-hand corner of the stamp.

Posters These have only been taken seriously as an art form since the brilliant achievements of Toulouse-Lautrec and others in the 1890s. Most of them at that time were hand-drawn and printed lithographically from huge slabs of stone. More recent ones have been produced photomechanically. See Bevis Hillier, *Posters*, London 1969.

Presses Each of the four main types of printing process requires a different sort of press, and each is discussed in its own section. So far only the relief press has found an historian: James Moran, *Printing Presses*, London, 1973.

Print room A room decorated with prints glued in attractive patterns and with drawn frames to the wallpaper. The fashion began about 1750 and lasted into the Regency period; examples can still be seen in several English country houses such as Stratfield Saye and Woodhall Park. The term is now also used for museum print study rooms.

Printsellers' Association A body set up by the print publishers of Britain in 1838 in order to regulate the number of proofs (qv) printed before the main edition of a plate. Members had to declare the exact number of proofs of every plate, and each impression was marked with the Association's oval blind-stamp, containing three letters in the centre which form a code identifying the particular print. A blind-stamp is therefore a certain sign that a print is a proof. The Association published complete lists of its members' publications, and these are an

invaluable index to Victorian print production.

Private plates In the eighteenth and nineteenth centuries plates, usually of portraits, were quite often commissioned privately from an engraver. The engraver would be paid an outright fee and the prints printed and distributed at the expense of the commissioner among his friends and acquaintances. Such plates were often lettered 'private plate', and since they were not published did not need to carry the normal copyright line.

Process block A term for any photomechanically produced block, often applied in particular to relief blocks.

Proof In its loose sense this word can be used for *any* impression of a print; for example the catalogue of Pennell's prints states that a print was published in an edition of 25 proofs. It should strictly be reserved for application only to those impressions which are printed before the regular edition. As explained in the entry for 'edition', this term has changed its significance in the course of time, and the significance of 'proof' has changed with it. In the early days a proof was an impression printed before work on the block or plate was complete – a 'working' or 'trial' proof. Sometimes such a proof was corrected by hand by the artist himself (a 'touched' proof). In the eighteenth century the concept became stretched when proofs of a finished subject but in 'uncompleted' states began to be published in what were really editions. In England this happened in the first place with mezzotints, a type of print in which it is very important to see an early impression before the bloom wears off; these were regularly issued before any letters, with scratched 'letters and finally with the proper engraved lettering (the last category often being called a 'print' to distinguish it from the others which were 'proofs'). Further refinements in the late eighteenth and nineteenth centuries were the signed 'artist's' proof, the 'open letter' proof, the multiplication of proofs on different sorts of paper (e.g. 'India paper' proofs), and the habit of actually lettering a print with the word 'proof'. In at least one case these letters were never removed, so that every single impression of that print is a self-described 'proof'. In another case (Frith's *Paddington Station*) precisely 3,050 proofs

preceded the main edition. What little justification such proofs had

disappeared with the introduction of the practice of numbering and limiting an edition, because printing would have finished before the plate had a chance to wear. However, in order to get round the awkward restrictions on the numbers of impressions, publishers have retained the so-called 'artist's' proofs, which are identical to impressions of the regular edition except for the manuscript annotations which identify it as a proof. On occasion the number of artist's proofs issued of a print has approached that of the main edition, but this is regarded as unethical.

Publisher Although some artists have marketed their own prints, most have worked through or for publishers. These have often put their address (i.e. name and place of publication) on the plate (see sv. lettering), or added their blind-stamp to each impression of a print. Publishers are in general one of the most important and neglected elements in the genesis of most prints. Cf. sv. edition.

Punched prints A technique invented by Jan Lutma. See p. 80.

Quality The quality of any impression of a print depends on three factors: the condition of the printing surface at the time of printing, the skill with which it was printed and the care taken to preserve it through the centuries. A cracked block or a worn plate will always produce an inferior impression; on the other hand even a block or plate in perfect condition can be poorly inked or badly printed. Finally the paper of an impression may have been torn, abraded or bleached, and however skilfully it has been repaired, the impression will always remain inferior.

Rarity The availability of a print depends on two factors; its rarity (i.e the total number of impressions surviving), and the demand for it. But demand increases as well as reduces supply. More than 90% of European print production is so unfashionable that it is unfindable. Rarity has often been artificially created, and it seems worth stating the obvious – that rarity has nothing to do with the quality of a print, although it may increase interest in it.

Registration The alignment of the various plates used in multiple-plate

114 Adriaen van Ostade *Old man leaning on a stick, c.* 1675. Etching (actual size). An early impression before the strong plate-tone in the upper corners had worn off.

colour printing. See p. 118.

Relief The class of printmaking process in which the printing surface stands in relief above the rest of the block. See pp. 13–29.

Relief etching A plate designed to be printed in relief from which the background has been etched away. See p. 29.

Remarques A 'remarque' is a scribbled sketch made by the artist on a plate outside his main design, to which it is often unrelated. The practice seems to have begun in the late eighteenth century as a way of testing the strength of etching acid on a plate before risking a biting of the main design, and was always burnished away before printing the main edition. This gave rise later to the deliberate manufacture of 'remarque proofs' where the remarque served no purpose whatsoever; remarques were even made on lithographs. At the end of the nineteenth century a few artists such as Félix Buhot made etchings where the remarques acted as a counterpoint to the main design and were left on throughout the edition.

Resist Another term for a ground (qv).

Restrike Any reprint of a plate made later than the main edition; it is often applied to printings made after an artist's death. A restrike will usually, but not necessarily, be an inferior impression.

Retroussage A technique used in wiping a plate to soften the line. See p. 34. The English term sometimes used is 'dragging up'.

Reversing images In order to get a print in the same direction as the original, the reproductive engraver had to reverse the image on his plate. This was usually done with a large mirror, which can be seen in many old views of the engraver in his workshop.

Rework A term used for any additional working done to a block or plate; it is often used with the implication that the new working has been added later in order to strengthen a worn plate, and has nothing to do with the original printmaker.

Rocker The tool used to roughen a plate for a mezzotint. See p. 85.

Rotogravure A name for machine photogravure when the printing surface is on a cylinder. See p. 125.

115 Francisco Goya *Por que fue sensible*, 1799. Aquatint (actual size). An unusual example of a plate worked entirely in aquatint. This impression is one of the earliest printed from the plate; it is one of only three known proofs before the lettering was added.

Por que fue sensible.

116 A late impression of **115**, showing the disastrous effect of the wearing of the aquatint grain.

117 Daniel Chodowiecki *Friendship and Compassion*, 1794. Etching (reduced). The two illustrations are etched on the one plate and have small *remarques* between them.

Roulette A wheeled tool used in some of the dot processes. See **69** and p. 80

Ruling machines Parallel lines, either straight or wavy, were often laid onto grounded plates in such areas as the sky. The ruling machines to do this were invented at the end of the eighteenth century in France by Conté and in England by Wilson Lowry. They found their widest employment in banknote engraving.

Screenprinting (French *sérigraphie*; German *Serigraphie*) A method of stencil printing through a mesh. See pp. 110–13.

Seal prints A name which has been applied to fifteenth-century embossed prints; only two examples are known.

Serigraphy An attempt has been made to distinguish commercial from artistic screenprinting by christening the latter type *serigraphy* and this term is normally used on the Continent. Since there is no difference whatsoever in technique between screenprinting and serigraphy, the term only causes confusion. There is also the problem of deciding when a print can properly be called 'artistic'.

Siderography A process to produce an unlimited number of exact replicas of an engraved plate by making a cylindrical mould of case-hardened steel. This was essential for the production of banknotes and postage stamps.

Signatures From the earliest period artists have added their monograms or names to the design on their blocks or plates. This seems to have been regarded as a sort of copyright mark, for it was only Dürer's monogram that Marcantonio was forbidden to pirate (see p. 44). Manuscript signatures first appear very occasionally on prints in the eighteenth century; the British Museum has a 1777 print signed on the verso by Janinet. The practice was only systematically developed for the benefit of collectors in the 1850s, when unlettered proofs of large reproductive engravings were published signed by both artist and engraver. Seymour Haden and Whistler are said to have been the first etchers to have signed their prints. The custom rapidly spread in the 1870s, and for a short period around 1900 the printer frequently added his signature as well. The practice is now so common that it is often (quite wrongly) taken as a defining characteristic of an artist's print, and a print without a signature loses much of its value commercially, (see p. 11). Picasso was hounded for years by dealers trying to get him to sign prints. Those who persist in thinking that signatures have significance may reflect on the story of the pile of sheets of paper seized on the Spanish border by French customs officials, which were all blank except for the signature 'Dali'.

Silkscreen The term usually used in America for screenprinting; the British term however seems preferable since the mesh used is not necessarily of silk.

Soft-ground etching (French *vernis mou*; German *Weichgrundradierung*) The process in which a drawing is made on a sheet of paper on a soft etching ground and thence transferred to the plate by etching. See pp. 99ff.

Splatter The technique of creating tone in lithography by spattering lithographic wash on the stone. See p. 101.

Staging-out Another term for stopping out (qv).

States In the process of making a print an artist often prints a few proofs at different stages of his working to check progress; any impression which shows additional working on the plate constitutes a different state, and catalogues of an artist's prints have traditionally confined themselves to the business of describing as many states as they can find. The classic case of this is with the prints of Rembrandt; the major

and minor changes he made to his plates have been minutely described in (so far) fifteen catalogues, and it has now become a major triumph to find a new state. Rembrandt himself does not seem to have gone through more than eleven states on one print; Degas went up to twenty. In the nineteenth century some artists exploited collectors' desire to own rare states by deliberately and unnecessarily multiplying them. It should be mentioned that there are numerous complications in describing and defining states. It is generally agreed that only intentional changes to a plate count – not accidental scratches. But one difficulty arises when different editions of prints show no change of state (eg. Piranesi, Goya), in which case editions have to be described independently from states. Another difficulty crops up in eighteenth- and nineteenth-century reproductive prints; with these, progress proofs are so multiplied that it becomes hopeless (and fruitless) to try to describe them all, and it has been customary to hive these off as 'proofs' and to say that the first state begins with the first published edition – which will (to complicate matters still further) usually be an impression before letters and before the regular lettered edition. In these cases a state becomes something quite different from a Rembrandt state, since Rembrandt's prints were never lettered and hardly ever reached a stage where one can talk about an edition.

Steel facing (French *aciérage*; German *Verstählung*) A process patented in 1857 whereby an extremely thin coating of steel is deposited by electrolysis on a copper plate. This immediately revolutionized the print business because plates could no longer become worn; if the steel did wear out another layer could be added, and at any time the steel could be simply removed by reversing the electric current. Connoisseurs have disagreed whether steel facing causes deterioration in the quality of an impression. In general this only seems to be the case with drypoints. See p. 74.

Steel plates These were introduced in the 1810s and were mainly used for mezzotint and engraving. In the case of engraving they demanded a different manner of working, and as a result steel engravings can usually be easily recognized. See **28** and p. 35.

Stencil Prints have in the past often been hand-coloured through specially cut stencils, and this still happens in France (see sv. pochoir). A new application of stencils has been in screenprinting. See p. 110.

Stereotypes A metal cast made, especially from wood-engravings, by means of a mould. The process was patented in France in 1829 and was vitally important for the development of wood-engraving since it dispensed with wood in favour of metal which could be printed in the new machine presses. Stereotyping was made obsolete by the invention of electrotyping in 1839.

Stipple An intaglio process in which tone is added by numerous dots. See pp. 82ff.

Stopping out The technique used in etching to make the acid bite to different depths. See p. 58.

Sugar (-lift) aquatint A method of defining areas to be aquatinted on a plate. See p. 93.

Sulphur prints Two quite distinct things can be called sulphur prints. (1) In Italy in the fifteenth century sulphur casts were sometimes made of niello plates, and impressions were occasionally taken from these on to paper. (2) In the seventeenth and eighteenth centuries sulphur was sometimes used in a similar way to aquatint for giving tone to a plate; prints from such plates may be referred to as sulphur prints, or as prints with sulphur tone. See p. 93.

Surface printing The method of lithography. See also sv. planographic printing.

Surface tone Tone created in an intaglio print by leaving films of ink on the plate in the wiping; this can be accidental and due to the incompetence of the printer, or deliberate as with many impressions of Rembrandt. See p. 37. It is to be distinguished from plate tone (qv).

Taking out A term often used of the removal of sections of an image from the printing surface; it is applied especially to the removal of the lettering from a print. Letters can, for example, be taken out to create a false first state.

Textile printing Western textiles have from very early times been decorated by means of printing from woodblocks or (from the mid-eighteenth century) copper plates. This area of the history is customarily ignored by the print historian. See Peter Floud, *English Printed Textiles*, London (Victoria and Albert Museum), 2nd. ed., 1972.

Tint-stone A second stone often used in early lithography to add relief and colour. See p. 120.

Tone-block Used to make a chiaroscuro woodcut. See p. 116.

Tradesmen's cards Many engraved or etched designs survive from the eighteenth and early nineteenth centuries carrying the name, address and business of a tradesman. These were apparently used for bills and distributed as advertisements, and as a result no pains were spared to make them attractive and appealing. Two fine collections, mostly of British cards, (the Banks and Heal) are in the British Museum. See Ambrose Heal, *London Tradesmen's Cards of the XVIII century*, London, 1925.

Transfer lithography The process whereby the artist draws his image on specially prepared transfer paper from which it is transferred to the lithographic stone. See p. 103.

Transfer printing A method of decorating enamels and ceramics; an ordinary engraved plate is printed on to paper in a special ceramic ink. The image is then pressed against the surface of the object to be decorated and thus transferred. The process was invented in England in 1753 and widely practised.

Transparent prints A process invented and published by Edward Orme in his *Essay on Transparent Prints*, London, 1807. An ordinary etching or engraving was hand-coloured both on the front and, in reverse, on the back. The highlights were then varnished on both sides, and thus the paper became translucent when held up against the light.

Trimming See sv. margins.

Tusche The German word for wash ink; tusche lithography is simply lithography where the image is drawn in wash. See p. 101.

Vignette The name applied to small decorative prints without definite border lines used in book illustration. When placed at the beginning of chapters they can be called head-pieces; when at the end, tail-pieces or

culs de lampe (qv). The great age of the vignette was in France in the eighteenth century, when some highly-talented artists such as Charles Eisen devoted almost all their energy to their production; it was also much used in England in the nineteenth century.

Wallpaper Woodcut blocks were used for printing wallpaper from the sixteenth century; colouring was often added through stencils and flock was sometimes used for decoration. Some important woodcut artists were closely involved in the wallpaper business, including Papillon in France and Jackson in England. See E. A. Entwisle, *The Book of Wallpaper*, 2nd. ed., Bath, 1970.

Watch papers A group of circular engravings, made from about 1740 to 1840 and about an inch in diameter, which were intended to be used as liners placed between a watch and its outer case. They often show subjects of topical interest.

Watermarks From an early period in the history of papermaking, manufacturers have often distinguished their product by means of watermarks (see sv. paper). These can sometimes yield valuable information about the origins or dating of a print. The standard dictionary is C. M. Briquet, *Les Filigranes*, 4 volumes, Geneva, 1907, but this only goes up to about 1600 and has to be supplemented by W. A. Churchill, *Watermarks in paper in Holland, England, France ... in the XVII and XVIII centuries*, Amsterdam, 1935, and E. Heawood, *Watermarks mainly of the XVII and XVIII centuries*, Hilversum, 1950. Briquet assigned dates to his watermarks on the basis of dated documents in the archives of Europe. For this reason they can only be regarded as approximate. Furthermore watermarks can only give a *terminus post quem* for prints and drawings, and it is always dangerous to use them as grounds for any precise dating. The danger is less with the paper made in England by Whatman which often has the actual year of manufacture in the watermark. But the date 1742 found on some French paper is a trap: it merely shows that the paper was made in compliance with some regulations imposed in that year.

White-line wood-engraving Writers have sometimes drawn a sharp distinction between black- and white-line wood-engraving. The difference, which can be seen in illustration **121** overleaf, depends on whether the design is carried by black lines set against white (the usual woodcut way), or by white lines incised in a black field (which has been regarded as the 'true' method of wood-engraving). The two types, however, become indistinguishable when the black and white are of equal weight, and for this reason, and because the white-line method can be used in woodcuts as well (see p. 9), it seems a mistake to lay too much emphasis on what is a distinction of design rather than of technique.

Woodburytype An image half-way between a print and a photograph, and in appearance much like an autotype (qv). A relief carbon photographic print was impressed into a lead mould. Prints were obtained from this by pouring in gelatine and laying paper on top. These prints of hardened gelatine had an uneven surface but considerable depth of tone. The process was much used in Victorian book illustration.

Woodcut (French *gravure sur bois*; German *Holzschnitt*) A process in which the lines of the design are left standing in relief on the block. See pp. 13ff.

Wood-engraving (French *gravure sur bois debout*; German *Holzstich*) A version of woodcut using an end-grain block and a burin. See pp. 21ff.

Xylography An unnecessary term sometimes used for woodcut (*xylon* being Greek for wood).

Zincography A term sometimes adopted from the French, who habitually draw a distinction between a lithograph on stone and one on zinc. Since the two sorts of print can very rarely be distinguished from their appearance the distinction is not worth making, except for the purist who feels himself unable to call something printed from zinc a lithograph (literally, a 'stone drawing').

118 *left* Anonymous, *Jack of Goats*, French, published by Christian Wechel, 1544. Woodcut (actual size). One of a set of Humanist playing cards. Colour was applied through a stencil, as can clearly be seen on the left sleeve.

119 *right* J. Austin *Trade Card of William Keeling*, c. 1767. Etching (actual size). A fine example of a rococo trade card. On the reverse is a receipt for 2s 8d for a month's supply of buns to the Earl of Guilford.

Keelings Pastry,

At the Cock in New Bond Street,

LONDON.

Makes all sorts of Rich Cakes,
Dyet Bread &c. Godiveau Pies,
Patties &c. Croquantes, Baskets,
Snuff Boxes, & all sorts of Cutt
Work done in the neatest manner,
Lemon, Orange, Tansey, & all
other sorts of Puddings, Potted
Wheat Ears, Fine Orange
Gingerbread, Captains
may be Serv'd with Fruit
& Mince Meat
for Sea.

Austin J. F.

For a Watch-Case

Sold by ɏ Proprietor R. Forreſt at ɏ Plume of Feathers
in Windmill Street St. James's London. Pr. 3 d. Plain.

120 Anonymous, *William, Duke of Cumberland,*
English, *c.* 1750. Engraving (actual size). By cutting
along the indentations, the print can be made to fit
into a rounded watch case.

121 Joan Hassall *The night drive*, 1937. Wood-engraving .
(actual size). An example to show the 'white line' and 'black
line' in wood-engraving. The trees are defined by the white
lines cut into the block; the houses, however, are defined by
black lines.